Il conformista

[The Conformist]

Christopher Wagstaff

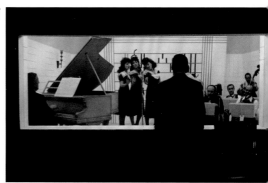

A BFI book published by Palgrave Macmillan

First published in 2012 by
PALGRAVE MACMILLAN

on behalf of the

BRITISH FILM INSTITUTE
21 Stephen Street, London W1T 1LN
www.bfi.org.uk

There's more to discover about film and television through the BFI. Our world-renowned archive, cinemas, festivals, films, publications and learning resources are here to inspire you.

Palgrave Macmillan in the UK is an imprint of Macmillan Publishers Limited, registered in England, company number 785998, of Houndmills, Basingstoke, Hampshire RG21 6XS. Palgrave Macmillan in the US is a division of St Martin's Press LLC, 175 Fifth Avenue, New York, NY 10010. Palgrave Macmillan is the global academic imprint of the above companies and has companies and representatives throughout the world. Palgrave® and Macmillan® are registered trademarks in the United States, the United Kingdom, Europe and other countries.

Front cover design: Eda Akaltun
Series text design: ketchup/SE14
Images from *Il conformista*, © Mars Film, S.p.A.; 8½, Cineriz di Angelo Rizzoli/Francinex; *The Killing of Sister George*, © Palomar Pictures International, Inc./The Associates & Aldrich Company, Inc.; *Tirez sur le pianiste*, Les Films de la Pléiade

Set by Cambrian Typesetters, Camberley, Surrey
Printed in China

This book is printed on paper suitable for recycling and made from fully managed and sustained forest sources. Logging, pulping and manufacturing processes are expected to conform to the environmental regulations of the country of origin.

British Library Cataloguing-in-Publication Data
A catalogue record for this book is available from the British Library
A catalog record for this book is available from the Library of Congress
10 9 8 7 6 5 4 3 2 1
21 20 19 18 17 16 15 14 13 12

ISBN 978–1–84457–369–1

Contents

Preface

I am a teacher of the humanities in a university whose job is to cajole and persuade young people to pay close attention to literary and cinematic artefacts which, let's face it, I impose upon them.
The reader of this book is a free agent in a market; nevertheless, that is the spirit in which I sit down to write this book. As a teacher, I am not alone, but one of many committed to the same endeavour: as I write this book, Arrow Films is preparing the UK release of a DVD of *Il conformista* (*The Conformist*), and a colleague, David Forgacs, is recording a commentary to accompany the film. My book is constrained by the format of the *BFI Classics* series, and David's commentary is constrained by the length in minutes of the film; I can't say all that I'd like to, nor can he say all that he really needs to. To hell with the market and the freedom of the consumer. My clients are urged to buy the Arrow Films DVD, watch *Il conformista*, then listen to David Forgacs' commentary and then delve into this book for more exploration of an artefact that will reward all the attention they are willing to pay it. That way I can relax knowing that some of the things I have to leave out are covered in David's commentary.

'Il conformista'

Background

In 1925, the young Alberto Moravia was convalescing from tuberculosis in a sanatorium in the Dolomites when his cousin, Carlo Rosselli, drove up from Rome to visit him. Both were anti-fascists, but Carlo's anti-fascism took the form of a liberal idealism (we would call him a social democrat, and he was very close to the British Labour Party at the time), in which an enlightened pursuit of individual self-interest was seen as gradually leading to a more rational and equal society. From this perspective, fascism was an aberration, a failure to understand how real historical progress actually took place, and a deviant digression in the march of history. Carlo and his brother Nello founded a Paris-based anti-fascist movement called *Giustizia e Libertà* (Freedom and Justice), many of whose members fled from fascist repression into exile in France. Meanwhile, however, Alberto's anti-fascist political ideas were much closer to those of the Italian Communist Party, according to which fascism was nothing other than the true face of bourgeois capitalism. Faced with opposition from the working classes, the ruling classes abandoned the pretence of democratic social consensus and took up the weapon of violent, repressive domination. Basically, if workers tried to go on strike, fascist thugs would be hired to beat them up. For someone like Alberto, fascism was not a historical aberration, but was the true, clearly visible reality of liberal capitalist society, undisguised by cultural and ideological smokescreens. The opponents of fascism were, therefore, not bourgeois intellectuals, who were in no way threatened economically by the way the fascists were ruling, but the working classes, whose pay and working conditions were kept down in order that the bourgeoisie could extract more profit from them. The way to fight fascism was by direct struggle, in the

factories and in political organisations. Seen from this Marxist perspective, while the intellectuals of the *Giustizia e Libertà* movement might well criticise the philosophy of fascism, their anti-Marxism meant that their objections to fascism were more a matter of aesthetics and philosophy than of material repression: their own freedoms were curtailed more by censorship and vulgarity than by economic deprivation.

I am exaggerating and compressing here. What we know of Alberto Moravia's political position comes from things that he said much later in life; and I am aiming above all to clarify the politics of the film that Bertolucci would later make of Alberto's novel about the death of his cousin.[1] Because, on 9 June 1937, the fascist secret service, fed up with the anti-fascist propaganda activities of the Rosselli brothers emanating from Paris, arranged for local thugs in the Cagoule to murder them in the French countryside, which they did by blocking their car from in front and behind, in a way similar to the assassination of Professor Quadri in *Il conformista*. In 1949, Moravia wrote a novel around the murder of his cousin, with the aim of writing about fascism from the inside, from the perspective of a fascist, rather than from the external perspective of an anti-fascist critic of the regime. He called the novel *Il conformista* (*The Conformist*), and it was published in 1951. It gives a linear, chronological account of how the child, Marcello Clerici, becomes aware of an aggressive impulse inside him, acting like an inexorable Fate, which is destined to make him graduate from destroying plants, to killing animals, and eventually to becoming a murderer. He is won over by the offer of a pistol from a homosexual chauffeur and, confused by the man's advances, shoots him. Checking the newspapers confirms his belief that he has killed him. To cover up his abnormality as a murderer and his doubts about his sexuality, he marries the most conventional middle-class girl he can find, and embraces orthodox fascism to the extent of enrolling in the political police, with the plan of spying on his former philosophy professor, who is directing anti-fascist activities from exile in Paris. On his

honeymoon, he leads his secret service colleague to the professor, and returns to Rome, where he later hears how the murder of the professor and his wife took place. The story jumps to July 1943 and the fall of Mussolini, when in a park in Rome he encounters in living flesh and blood the very chauffeur he thought he had killed. Evacuating the city, his car is strafed by a fighter aircraft, acting like a *deus ex machina*, and he and his wife and daughter are killed.

Moravia's novel was nourished in rich soil. In 1940, Jean-Paul Sartre had been awarded the *Prix du roman populiste* for his 1939 collection of five short stories entitled *Le Mur*, the most substantial of which was a novella, *L'Enfance d'un chef* (*The Childhood of a Leader*), telling the story of Lucien, the son of a factory owner, who grows up insecure about his identity, but would like to be a leader like his father.[2] He reads Freud, and has an unsatisfactory homosexual experience with an older man, which leads him to compensate by taking up rather half-heartedly with a woman. He also falls in with right-wing anti-Semitic students and participates in violent attacks on Jews, escalating to murder. He sees his future as a leader of France.

Moravia himself writes in 1941 a short novel, *Agostino*, published in 1944, on a clearly oedipal theme about a youth who is also disturbed by a homosexual encounter. Moreover, it is almost inconceivable that Moravia's interest in Freudian psychoanalysis didn't bring him into contact with Freud's most famous case history, that of 'The Wolf Man', revolving around oedipal conflicts, repressed childhood seduction and insecure sexual orientation. A highly regarded fellow collaborator on literary journals, Carlo Emilio Gadda, had written an essay-novel in 1945, *Eros e Priapo*, in which he carried out what one can only call a hugely strenuous and vituperative psychoanalysis of the phallocentrism and cult of virility of Mussolini and the Fascist Party. Some parts of it were published in Pier Paolo Pasolini's literary journal *Officina* in 1955, but the novel as a whole was not finally published until 1967, creating a furore in 1968, shortly before Bertolucci was to embark upon making *Il conformista*.

In 1969, Bernardo Bertolucci was making a film to be shown on television, loosely based on a Borges short story, called *Strategia del ragno* (*The Spider's Stratagem*), in which a young man returns to his home town to investigate the murder of his anti-fascist father, a middle-class intellectual. He learns that his father and a group of conspirators had planned to shoot Mussolini at the climax of a performance of Verdi's *Rigoletto* in the town's opera house. Instead, according to all accounts, his father had been shot in his box at the opera by a fascist, and was celebrated in the town as an anti-fascist martyr. The son discovers that in actual fact the father had chickened out of the planned direct action against fascism (the shooting of Mussolini), and had told the police about the plot, whereupon Mussolini's visit to the town had been cancelled. He had confessed his betrayal to his fellow conspirators, and had made them the following proposal: that they should shoot him in the opera house, just as they had intended to shoot Mussolini, but they should put the blame on fascists, and therefore create a martyr who would dominate the history and culture of the town for decades into the future. I shall add here a little interpretation, because the film is never explicit about why the father betrays the plot to kill Mussolini. And the suggested interpretation relates to what I have just said about *Il conformista* above. The father is a middle-class intellectual anti-fascist who is threatened by fascism not materially and economically but above all aesthetically – it is vulgar. Bourgeois intellectuals do not go around shooting people to achieve their goals, because it is much more effective to create a story, a narrative, a 'history' which will determine future generations' view of how the world is. So the father arranges a performance whose message persists into posterity. Bertolucci ends his film by having the son find it impossible to reveal the truth that he has uncovered. The historical account of a martyr to anti-fascism is allowed to persist unchallenged. And this is Bertolucci's way of expressing his rebellion against the experience of a young Marxist intellectual trapped in a mythical or legendary version of Italy's political history in 1969,

according to which the previous generation had been characterised by its 'resistance' to fascism.

While he was getting ready to shoot *Strategia* (it was shot in the summer of 1969), his girlfriend, Mapi (Maria Paola) Maino (an expert in design between the wars), was reading Moravia's novel *Il conformista*, and recounted to him in detail the story of the book. Bertolucci was so taken by the story that, before even reading the novel himself, he took the proposal for a film to Paramount's Italian production affiliate, Mars Film. Paramount approved the idea in September 1969, and arranged for the film to be financed to the tune of just under $1 million by a newly formed joint venture between Paramount and Universal for the distribution of their films outside the United States called CIC (Cinema International Corporation). To benefit from the support that European countries gave to their own national cinema industries, the funds were funnelled through an Italian production company, Mars Film, and a French company, Marianne Productions, in an Italo-French co-production arrangement, with the co-participation of the German company Maran Film. Shutting himself away for a month with a typewriter and a copy of the novel, Bertolucci produced a script, and that autumn work on the film began (completed in January 1970), with Bernardo's cousin, Giovanni Bertolucci, in charge of production. Bernardo's transposition of the novel into film was in some respects quite a free one, but it was enthusiastically greeted by Moravia himself, who was a close friend of the 28-year-old film-maker.

Just as Moravia's novel did not blossom in a vacuum, neither did Bertolucci's film. For a number of years after World War II, Italians had been reluctant to examine the past, and in particular the two decades of fascism, and an orthodoxy reigned in Italy, according to which the fall of fascism, the Allied liberation and above all the Resistance movement constituted a historical watershed, dividing authoritarian, totalitarian fascist Italy from the post-war democratic Republic. Italians had rejected fascism in what amounted to a civil war, and the wounds should be quietly left to heal. In the 1960s,

writers, historians and political scientists began seriously challenging this vision, investigating whether it really was plausible to assert a break between fascism and post-war Italy. Rather than treating fascism as some unknown, untouchable horror to be hidden away, they asserted the need for study and research, investigation and discussion. In the second half of the 1960s, a younger generation challenged the myth of the Resistance as legitimising the authority of their parents' generation. All began acknowledging a greater degree of continuity between fascism and bourgeois free-market capitalism, and started seriously questioning whether Italian society really had risen up against fascism and founded a true democracy on the basis of that resistance. Bertolucci's two films of 1970, *Strategia del ragno* and *Il conformista*, are key cultural manifestations of this intellectual climate.

It would, moreover, be difficult to exaggerate how closely knit the Italian cultural and artistic world was in the 1960s. The young Bertolucci was part of Moravia's circle, which included Pier Paolo Pasolini, the homosexual poet, writer, scriptwriter and film-maker, with whom Bertolucci worked closely. Mauro Bolognini filmed Moravia's *Agostino* in 1962, highlighting its homoerotic content. The Ferrarese writer Giorgio Bassani, working for the same literary reviews as Moravia, published in 1956 a volume of five short stories, one of which Pasolini helped adapt for Florestano Vancini's 1960 film, *La lunga notte del '43* (*It Happened in '43*), where fascist betrayal is linked to sexual inadequacy, and where the protagonist witnesses fascist murders and does nothing. Bassani's 1962 novel, *Il giardino dei Finzi-Contini* (*The Garden of the Finzi-Continis*), about fascist persecution of the Jews in Ferrara went through a number of attempted adaptations, until in 1968 it was entrusted to the veteran neorealist director Vittorio De Sica, whose film of the novel was released in 1970, starring the same Dominique Sanda whom Bertolucci would choose for his film, alongside Helmut Berger, Visconti's companion, in the role of a repressed homosexual. As mentioned earlier, the publication in 1967 of Gadda's sexual

psychoanalysis of fascism in *Eros e Priapo*, which had first appeared in Pasolini's literary review, caused a sensation. Everybody was reading Freud. In 1969, Bernardo embarked on a long course of psychoanalysis, to which he partly attributes the explosion of creativity which led to his subsequent films.

Collaborators

In his previous films, Bertolucci had used Roberto Perpignani as his editor, but Giovanni Bertolucci, the executive producer of *Il conformista*, insisted that this time Bernardo should accept as editor Franco (Kim) Arcalli, who had worked as scriptwriter with Tinto Brass and as an innovative editor on the films of Giulio Questi. Bertolucci himself is the first to admit the enormous influence Kim had on *Il conformista*, as will become amply evident when we begin to examine the film. Arcalli's pupil, Gabriella Cristiani (who went on to edit Bertolucci's films after Arcalli's death), goes to the heart of his method:

Kim didn't assault so much the filmed material itself as the structure. He intervened strongly on the structure. Normally editors do it after the first rough cut. Instead Kim, being also a scriptwriter, did it straightaway. ... His slogan was 'Let's turn everything upside down!' ... He didn't just limit himself to trimming and linking together the shots; he bothered about the structure and the narrative of the film.[3]

The cinematographer, Vittorio Storaro, was something of an *enfant prodige* in his profession, rapidly rising from student at the Centro Sperimentale di Cinematografia, to assistant camera operator (on Bertolucci's *Prima della rivoluzione/Before the Revolution*, 1964), to cinematographer in 1968. He belongs to a post-war generation of cinematographers who challenged many of the orthodoxies adhered to by the veterans, and in Storaro's case this concerned particularly a narrative use of light and the exploitation of colour temperature. His collaboration on *Strategia del ragno*

resulted in a unique twilight world of blue lit up with warm yellows, and this contrasting binary pair is used to great expressive effect in *Il conformista*, where a Parisian honeymoon is given a sinister and ominous cold blue tone, punctured by bright, warm fantasies of projected wish-fulfilment. Film-makers were so impressed by his work on *Il conformista* that the film launched an international career for him.

The production designer, Ferdinando (Nando) Scarfiotti, had trained as an architect, but quickly started designing stage productions for his uncle, Luchino Visconti, and later for his films. He and Bertolucci, scouting for locations, saw beauty in the despised architecture of the fascist World's Fair complex, EUR, in Rome, and used it to such good effect that an American architect told Bertolucci: '*The Conformist* was a fundamental film for young American architecture. We have heard a lot about fascist architecture; we read books about it and saw documentaries on it, but it was only in your film that its real face was revealed.'[4] Bertolucci said of Scarfiotti: 'He was more than a collaborator, he was more like a brother, or even a mirror image. ... We realised that we shared many feelings, about the history of taste, in some way. And also the desire to dive into beauty – a bit out of control, I must say!'[5] Only two sequences used studio sets: the train, because it required back-projection (the landscape through the windows), and the EIAR radio studio, of which Scarfiotti said: 'It was made from an old kitchen set which I had to make in one day.'[6] Neither Bertolucci nor Scarfiotti had any direct experience of the inter-war period, because they were both too young:

Usually, in a case like this, you use photographs, books, newspapers of the period. Instead, my suggestion – and Bernardo welcomed it – was to ignore that type of source-material and draw upon the films of that era, not just Italian ones, but also foreign ones. We wanted a Fascist Italy that was abstract, very different from one based on historical documentation. So we didn't base ourselves on an authentic, historical image of that Italy, but on its image as reflected in the cinema of the *white telephone* films.[7]

One thing both of them were striving for was the biggest contrast possible between the Rome of the fascist regime and the Paris of the Popular Front.[8]

Bertolucci's relationship with his collaborators emerges from something he said to his friend Enzo Ungari:

Knowing that the material I shot would end up in the hands of Kim [Arcalli], I persevered in my style of shooting. At the time I had beside me two very important figures for giving visual life to my ideas (even to the most obscure and confused of them): Ferdinando Scarfiotti and Maria Paola Maino. A great friend the first, a great love the second. And Gitt Magrini, who came up with the costumes for Sanda, Sandrelli and Marlon Brando [in the 1972 film *Ultimo Tango a Parigi/Last Tango in Paris*], lending a softness to their souls. My back was covered and I was well protected.[9]

For the role of Marcello he chose Jean-Louis Trintignant straightaway for his neurotic quality, without even doing a screen test. He told Marilyn Goldin (who, as well as interviewing him for the journal *Sight & Sound*, played the woman selling *les violettes de Parme*):

He is acting. Still, I think Trintignant is *that* person, that this is the first film in which he is himself. If he reads this, he's going to be furious. But I chose Trintignant because when I think of him two adjectives immediately come to mind: moving and sinister. And these are qualities of the character. The point of departure is reality, then the actor transcends it.[10]

Even before Bertolucci said this to Marilyn Goldin, Trintignant himself confirmed the accuracy of the assessment in an interview for French television: 'I've never had a role for which I was asked so much, so many things which I have inside, but that I hide. ... I'm embarrassed to say this now, however, considering all the films I've done, I think *The Conformist* is absolutely the most beautiful of all those I've played in.'[11]

Bertolucci searched around for an actress to play Anna, and even went to talk with Brigitte Bardot. Then he saw Robert Bresson's film *Une Femme douce* (1969) in which the teenage fashion model Dominique Sanda was acting for the first time. Because he wanted her to represent the kind of ideal expressive opposite to Giulia, the wife of his conformist, Bertolucci had her play the mistress of the fascist minister and the prostitute in Ventimiglia as well, so that when Marcello finally meets Anna, the viewer would intuit her mysterious attraction for him. At the very same moment, De Sica saw Bresson's film, and chose Sanda for the cold, mysterious beauty of Micòl Finzi-Contini. Stefania Sandrelli had been pitched into instant stardom at the age of sixteen by Pietro Germi's use of her in *Divorzio all'italiana* (*Divorce Italian Style*) in 1962, and she had also had an important role in Bertolucci's *Partner* of 1968. Interesting is the use Bertolucci made of performers from Italian cinema's past: Fosco Giacchetti, one of the most popular male leads of fascist cinema, as the Colonel; Yvonne Sanson, star of Rafaello Matarazzo's enormously successful tearjerkers at the start of the 1950s, as Giulia's mother; and Milly, star of the 1930s, as Marcello's mother.

Narrative

The editor, Kim Arcalli, came to the film with experience of twisting stories back on themselves through a fragmented narrative reordering; but so did Bertolucci, who from his very first film (*La commare secca/The Grim Reaper*, 1962) had twisted round the linear, horizontal succession of narrative components of a film so that they constituted a layering of time in depth. I'm using a spatial metaphor here for time: if linear chronological time moves from left to right, Bertolucci turned it so that it went from the end of my nose far into the distance away from me, in a layering of veil behind veil behind veil. This enabled him to use time as his tool for penetrating beneath surfaces – for example, beneath the surface of the conscious mind to the unconscious deep within. This is what gives *Il conformista* its unique narrative structure. A synopsis of the plot goes as follows.

It is 1938, and Marcello Clerici is being driven by an Italian political police agent, Manganiello, to a place where he will supervise the assassination of his former philosophy professor, Luca Quadri, who directs anti-fascist missions from Paris where he has fled the fascist regime. The film proceeds in a series of flashbacks leading to this car journey. Marcello is in a radio studio, discussing his impending marriage to Giulia with Italo, his blind, gay friend who broadcasts fascist ideological sermons. Marcello offers to spy for the political police on Quadri while on his honeymoon in Paris. He visits Giulia to discuss the wedding, and then his mother, who lives in chaos and takes drugs procured for her by her Japanese chauffeur, who is also her lover. While walking to his mother's house, he has been accosted by Manganiello, who informs him that they must contact another agent in Ventimiglia for further orders. Emerging from his mother's house, he has Manganiello beat the chauffeur and order him away. He visits his father, together with his mother, in a lunatic asylum, and when he asks him about his fascist past, the father demands to be straitjacketed. Before the wedding, Marcello goes to confession, and remembers his boyhood seduction by a chauffeur, Lino, at the end of which Marcello shot him, presumably killing him. Next, Marcello is at a pre-nuptial party for the bridegroom thrown by Italo and his blind community, at which the two friends discuss the way fascism offers people an antidote to the anxiety of feeling 'different'.

On the way to Paris by train, while Giulia recounts to Marcello her seduction at the age of sixteen by an elderly family lawyer, Marcello makes love to her, and at Ventimiglia is told that Quadri is to be killed. Once in Paris, he visits Quadri and his wife, Anna. He falls for her, while she detests him, but being lesbian, fancies Giulia. Quadri and Marcello discuss Plato's myth of the cave, and apply its meaning to fascist Italy. Marcello visits Anna at the ballet school where she teaches, and learns that she knows he is in Paris to destroy her husband. He returns to his hotel room to find Anna trying to seduce Giulia. The Clericis and the Quadris go dancing at Joinville, followed and observed by Manganiello. Anna and her husband are going to spend a weekend in Savoy, and when Anna decides to stay behind in Paris with the Clericis, Marcello tells Manganiello Quadri's route, so that the assassination can take place during the journey without harming Anna.

The next morning, Marcello receives a telephone call in his hotel room from Manganiello to say that Anna has left with her husband after all, and he leaves with Manganiello to pursue their car, hoping to save Anna. They catch up with the Quadris' car at the point where the assassins come out of the trees, stab Quadri and chase Anna, shooting her.

In an epilogue, set in July 1943, when Mussolini was deposed, Marcello goes into the streets of Rome together with Italo, and encounters a man picking up a male prostitute. The man is Lino, the chauffeur whom he thought he had killed as a boy. Marcello denounces Lino and Italo as fascists, and Lino in particular as the murderer of Quadri and his wife in 1938. A crowd of anti-fascist revellers sweeps Italo away, and Marcello is left looking at the male prostitute.

The order of the *fabula* – the events as they are supposed to have taken place – breaks into five parts:

1. Marcello's boyhood encounter with Lino (25 March 1917).
2. Events in Rome leading up to his marriage with Giulia and his enrolment in the political police: the EIAR radio studio, Giulia's mother's house, Marcello's mother's house, Marcello's father's mental asylum, premarital confession in church (which is where the boyhood encounter with Lino is inserted in the *syuzhet*, or plot), the stag party given by Italo's blind friends.
3. The journey from Rome to Paris: the train and the brothel in Ventimiglia.
4. Paris, and the meeting with the Quadris, which brings us to the present of the narrative: the car journey and the assassination (15 October 1938) in Savoy.
5. Epilogue: Rome (25 July 1943), and the fall of Mussolini, in which everything that went before is turned upside down.

On the level of the *syuzhet* – or the ordering of events in the film itself – the journey in the car supplies the narrative framework on the level of time; but it also serves another function, which is that

of the reference point for the associations of ideas. Movements in time are caused by associations of ideas (or memories), and those associations have Freudian significance, forming a sort of code, or key, to the meaning of the film. The car journey, therefore, constitutes a psychoanalytical session, which retrieves the past, the repressed, childhood sexuality, and brings it to consciousness, in such a way that the patient confronts it, which is what takes place in the epilogue. The moment of transference takes place at the assassination.

This temporal structure is paralleled, to a certain extent, with the same Freudian metaphorical implications, in the way in which the vision of the viewer penetrates into the psyche of Marcello, going through the windscreen of the car, and going through other panes of glass that at times reflect and at times reveal. The panes of glass (or sometimes iron grilles) are the barriers that are put between Marcello and reality, or between him and his unconscious drives, so that the film's montage is matched on the level of the *mise en scène*.

Mise en scène and montage

Every analysis of a film starts from certain assumptions about the film. I don't think *Il conformista* is an essay on politics or sexuality, or that it gives us reliable information about Italian society under fascism. These are my assumptions: that the film is, notwithstanding the contributions of important collaborators, the work of someone who sees himself as a poet, an individual artist, an author (Bertolucci described his attitude as he shot *Il conformista* as 'the strategy of auteur cinema; ultimately that author says: "I write, I shoot, I do the editing" '[12]); that it sets itself the task of assembling poetically evocative images rather than conducting a coherent, logical discourse, for which the freedom to respond to the performers, the images and sounds in an improvisatory way during the shooting is essential to the creative act ('the great passion I have always cherished for the set, for the moment of shooting, comes from the wide margin of improvisation it offers'[13]); and that, despite the enormous care and subtlety invested in the script and narrative, the

author has entrusted the beauty of the film, which is his ultimate goal, to matters of style ('Seeing beautiful films is the most stimulating thing there is'[14]). Bertolucci has gone to considerable lengths in long, careful and candid answers to questions to explain his approach to his craft, and so I shall start with a selection of his statements and confessions to give support and plausibility to the assumptions behind this approach to the film.

Bertolucci was being interviewed for *Sight & Sound*, and was responding to rather general questions when he erupted with this unprompted complaint: 'You know, I have done thirty interviews and no one ever asks me why I moved the camera in a particular way, or why I used tracking shots, or how long they were …', at which point he briefly describes some of the stylistic features of the dance-hall scene from *Il conformista*, and then continues: 'So these are the things … découpage, camera technique. It is only through technique that one arrives at doing things.'[15] He is quite explicit about his technical priorities: 'I am very meticulous and boring about camera movement', and in reply to the question 'Do you generally improvise your camera movements?' he was emphatic: 'No, no, no, they are very refined. They are very programmed.' 'All my pleasure', he says, 'is the camera. The movement is all my decision, and I think it corresponds to a certain idea of a visual music … Cinema is much closer to poetry and to music than theatre.'[16] His acknowledgment of the influence of Ophüls reveals how little interest he has in 'representation', for he describes images being projected, rather than captured, by the camera:

The extraordinary thing about Ophüls is musicality, the presence of the camera in the midst of a reality that almost seems to come out of the camera rather than be filmed by it, as though the camera projected all around it characters, settings, and spaces made especially for it to move around in. This way of filming seems to me fairly close to my notion of cinema, to my manner.[17]

This is how he describes his procedure on the set (and it is confirmed by witnesses who have watched and reported):

In general, I go into a room or on a location alone with my viewfinder, and I look at what's the main mood. I imagine a shot, I imagine movement, and I follow those movements. It's a very abstract thing. Then I call in the actors, and I do the same thing with the viewfinder. A kind of ballet, in general silence. Then I call Vittorio [Storaro, director of photography], and I try to verify if my first intuition was right or not.[18]

He has always insisted on the continuity between writing poetry and making films, which has enormous implications for a film-maker, drawing attention, as it does, to personal authorship, self-expression and the priority of lyricism over narrative. 'You see, making movies is like writing poetry. ... I believe that to edit a sequence of a film is like placing words in a poem.'[19] 'The secret of cinema lies in style, not in story. Style is what offers the viewer "the pleasure of the text", communicating to him, therefore, the creative passion of the author.'[20]

For a long time I thought that a movie was the expression of one person. That's why I started making movies when I was very, very young, and I was coming straight from the experience of being a poet. Poets like to work alone; even if they write their poems on a bus ticket, sitting on a crowded bus, they are alone. Also, it was the beginning of the Sixties when I started, and the idea of the 'auteur', the author, was very imposing. So, I was writing my films and I was directing my films, and I thought that I was alone on the set.[21]

I don't see any difference between cinema and poetry. What I mean is that from the idea to the poem there is no mediation, just as there isn't any between an idea and a film. If the idea isn't already poetic, there's no chance it will become so. I followed the same process in writing my poems and making my films.[22]

We find the director being equally explicit about the development of his approach to film editing:

I used to think very bad things about editing. I used to hate the idea of editing. *Partner* was really a minimum [*sic*] of editing because I wanted to make long shots. And then when I did *The Conformist*, Kim [Franco Arcalli], who was brilliant, a great editor, made me discover things in the editing.[23]

Anybody who is remotely familiar with the making of *Il conformista* is also familiar with Bertolucci's conversion to editing. People may be less familiar with what exactly he saw himself as being converted *from*. It might be helpful to listen to what Bertolucci said in 1968 shortly before he shot the film:

After [*Partner*] four years passed during which I did almost nothing. ... You can't just make films every four years. You completely lose the easy relationship you have to filming, you start attributing too much importance to every little thing. At times, I've found myself agonizing over every scene I've shot as if my life depended on it. That's not right. And then, during all those years when I wasn't filming I did almost nothing but think about film, about cinematic style, I don't know, about the fact that some shots are completely autonomous and that every shot is a film. Now, all that weighed on me as I was making *Partner*. I tried as often as possible to do shots that would be autonomous. Another idea in this vein is that I was obsessed for two or three years by the idea that it's during the editing that every film loses its stylistic violence, the moment when, cutting the stylistic 'misfits,' the whole film becomes leveled out. I think editing is the moment which stopped the history of the evolution of the cinema. Because shooting, even though you have to see things through the lens and tripod, the cameramen, etc., is a gestural and instinctive act which produces moments of authentic stylistic liberty. Editing was invented by the auteurs and instrumentalized by the production studios precisely to eliminate this freedom, to level everything. The American studios, in fact, retained by contract the right to modify the editing of their films. They even invented a term to designate this process: the final cut. At a certain point, I found myself almost paralyzed by these ideas: my uncut scene or death! etc. And in my films you can sense my desire to abolish editing, reducing it, when there is any editing at all, to its most elementary form.[24]

Partner was filmed in a period of neurosis. I had – as one has a persecution complex – I had a single-shot-per-scene complex, but just as like a neurosis, the montage was, as it were, abolished, and ended up as a sequence of shots which I'd conceived of as autonomous and which could be freely interchanged, alternated or combined. By contrast, *The Conformist* is a tightly edited film; there are lots of scenes. There is one five-minute scene in particular which is made up of close to two hundred shots![25]

The producer's imposition of the editor Franco Arcalli had enormous consequences. Bertolucci didn't really change his way of shooting; he was still stacking away, one after the other, almost self-contained, autonomous shots which offered a facility for being 'freely interchanged, alternated or combined'. Storaro, the cinematographer, is quite clear how things happened: 'When we started we didn't know that the story could be presented as a memory, as a flashback. We started in a kind of linear way.' Arcalli joined the team fairly late on, at the editing stage. Bertolucci himself tends to colour his account with hindsight:

I shot *The Conformist* leaving open the possibility of telling the story chronologically, as in Moravia's novel. Right from the start of shooting I was fascinated, however, by the possibility of using the car journey as the 'present' of the film, the container of the story. Basically, the protagonist journeys into his memory as well. As a result, I had shot a lot of material on Trintignant's car-journey. With a great editor like Kim [Arcalli], you find that you can gradually see the structure of the film materialising. The structure of a film is merely announced by the script and begins to exist and manifest itself during the shooting; but it is during the editing that it takes on its definitive form. A few days were all that was needed, just enough to see the first sequences of *Il conformista*, for my relationship with editing to change. I had taken to watching him at work, and it was a real sight to see the manual skill and familiarity of a true craftsman with which he handled the reels of film. I was impressed by the sureness of his times and rhythms, which he knew so well that he didn't have to check the cuts on the viewing machine. When he had to

splice together some short shots he measured them by eye, holding the film with his arm outstretched, like a draper measuring a piece of cloth. He would hold it against the light before cutting it and then would run the edited sequence through the moviola to see the result together with me. It was as if editing, which usually takes a horizontal movement from one spool of the moviola to the other, was taking place in vertical layers, one layer on top of another, each time revealing something deeper.[26]

I am using Bertolucci's own words to explain in general terms what he meant by 'It is only through technique that one arrives at doing things' in the *Sight & Sound* interview, and by 'I followed the same process in writing my poems and making my films' in the *Cahiers du cinéma* interview. We shall see what this means in practical, detailed terms in a selection of scenes. We also find in his own words the basis for an interpretation of just what the 'things' are that he is doing in *Il conformista*. First of all there is the important role that psychoanalysis plays in the film. *Strategia del ragno* was made a few months before *Il conformista*, and of the former he says that it was born 'two or three months after I had discovered psychoanalysis, that is to say at the moment of greatest enthusiasm for the Freudian encounter'.[27] 'In the book [Moravia's novel] the story of the conformist is a tragedy and, as in the Greek tragedies, everything is related to Fate. Here I substituted Marcello's unconscious – a psychoanalytic explanation, that is – for the presence of Destiny in the book.'[28] The film is not about historical fascism but about the 'relationship between the Italian bourgeoisie of the 1930s and of today (I am only interested in the psychological phenomenon)'. He has added to the material supplied by the novel 'the blind friend who works for the fascist radio … who I found useful … for establishing relations with fascism which are more symbolic than historical'; 'it is a film made about artifice, which tries to retrieve reality through artifice'.[29]

The director was conscious of using the lighting as an expressive code:

[Vittorio] Storaro [director of photography] is the paintbrush, Storaro is the colours, Storaro is the hand of the painter that I am not and never will be. Vittorio has always been able to bring to life – each time it seemed a miracle to me – an idea of light or of colour that for me were just words with which I visualised the story I had to tell … Vittorio is something more than a director of photography, he is a *metteur-en-lumière*.[30]

Storaro said many years later:

What united me and Bernardo was the fact of assembling a *mise-en-scène* that was not completely conscious. Bernardo always had need of symbols. …
In *Il conformista* light as consciousness, and darkness as unconsciousness.
The protagonist was trying to hide something in himself, and project onto the outside, as reality, something conscious. … I said, let us make a cage around Marcello, where there is an opposition between light and shadow. Bernardo liked the idea, and so we shot all the Rome parts in this claustrophobic way.
Then, when the character goes to Paris, we allowed light to embrace the shadow. No longer the same kind of separation. We start to see colour.[31]

Bertolucci calls the lighting of the dancing school (warm yellows) 'impressionistic' (I think he is referring to painters), and that of the adjoining room (cold blues) 'expressionist' – 'when she undresses she is going to the slaughterhouse; which is why I use that light'.[32] One is reminded of Kracauer's contention that the 'sleuthing motif' is ideally cinematic (because in it you penetrate reality to get at the 'truth')[33] when Bertolucci says: 'Let us say that what I would really like to do is use the methods of Raymond Chandler to talk about neuroses and existential facts rather than about crimes.'[34] *Il conformista* also uses stylistic characteristics of the crime-movie genre, because this genre of film supplied the period model, as Bertolucci explained when he was asked why he had called it a 'film about the memory of cinema':

I wasn't even born in the years when the events of the film took place, and so I had no memory of those times. The only memories I could turn to were the

collective ones of the films of the period. Those films (I'm talking above all about the films of Renoir – *Le Crime de Monsieur Lange*, *La Règle du jeu* – and American ones) helped me much more than reading documents or watching documentaries.[35]

Let us start by looking fairly closely at a passage from *Il conformista*, very near the beginning, set in an Italian state radio (EIAR – *Ente Italiano Audizioni Radio*) studio, material which is not derived from Moravia's novel, but which was imagined and scripted from scratch by Bertolucci. We start from the shot which is the central shot of the film, and to which the narrative keeps returning: that of Marcello sitting in the car, being driven to the place of Quadri's ambush by Manganiello – the eighth shot of the film.

8. Close-up of Marcello's face through the windscreen, with a wiper out of focus in the foreground, Marcello looking just past camera. No background music. Manganiello's voice, off camera (and sounding close, i.e. not really as it would sound in a moving car with the engine going; instead he talks quietly): *Bah! Who could have foreseen this, sir? ...*[36]

Shot 8, the anchoring of the narrative, Marcello being driven to the assassination

The sound of the whole film was post-dubbed, a device that Bertolucci does not like, but which he felt was necessary, given the nationality of the actors (though he claims to be the first director ever to have used Sandrelli's own voice for her role; and yet strangely, some of the most experienced Italian actors were dubbed). This allows him to give these scenes in the car the acoustic intimacy that reinforces their function as confessional scenes, part of a sort of psychoanalytical session. The film is a projection of Marcello's unconscious, and therefore there needs to be an air of the fantastic about what we see and hear. As a result, the whole film makes much use of voice-off, and this becomes close (as here) to voiceover. We do not see the owner of this voice until well into the film, when he appears to be 'tailing' Marcello to his mother's villa – and even then, we do not know who he is, and he is made more sinister by the fact that the sequence is shot with the camera rolled (by which I mean tilted sideways). The effect of shot 8 is enhanced by the fact that Marcello does not look at the speaker. We are instead immediately enticed into his reverie. The next few shots form a reverse-angle sequence between this shot of Marcello and buildings he sees passing by through the passenger window. The fact that we look at Marcello through the glass of the windscreen may not at this juncture appear significant. Later, however, Bertolucci will give us the same shot with the camera lens rack-focused onto the windscreen, and he will focus back and forth during the shot. That Marcello is inside the car, behind glass, viewed from the outside is an important part of the *mise en scène* of this shot, and of the whole film.

As for what Manganiello is saying, a viewer seeing the film for the first time is unlikely to understand what he is talking about, and indeed, experiments with students have shown me that some people seeing the film for the first time do not even remember having seen the opening shots at all. This would give rise to an enormous number of issues concerning perception of film narrative and redundancy in film language which I shall pass over, noting, however, that it does mean that the film Bertolucci made for Paramount to go the rounds

of the mass-market exhibitors actually presupposes a consumption
that its packaging tends to disguise. You think you have seen the film
when you get up to leave at the end. In actual fact, to see it in even a
rudimentary way requires several viewings, because the mind tends to
see only what it is looking for. Someone who had read the novel
would need fewer viewings, and this, of course, raises the question of
the extent to which the film as a communication is part of a larger
communication; Bertolucci has taken a narrative that was
pedestrianly chronological and painfully accessible (Moravia repeats
his every 'point' many times), and has made it achronological,
elliptical and far less accessible than it at first appears.

14. Marcello, as no. 8. Manganiello's voice-off: ... *Aren't you listening to me,*
sir? (Marcello twists his head slightly to camera right and then back to
looking ahead). Marcello whispers: *Yes, yes.* As he utters these words, the
introduction to a popular song of the time starts up quietly on the
soundtrack, and gradually increases in volume. Manganiello's voice-off
slightly suppresses the music, as he says: *Bah! A screw-up we really didn't*
need. Anyway, I'm just sticking to instructions. The music reaches full volume
(still the instrumental introduction) for two seconds, while the camera
holds Marcello.

The character whose face we are watching is on his way to
murder Quadri and his wife, the woman with whom he is in love.
This being so, the reverie flashbacks to the time of his marriage to
Giulia and, in particular, the girls in bright light singing *Chi è più*
felice di me! ['Who Is Happier Than Me!'] are entirely appropriate as
part of a wish-fulfilment repressive activity in Marcello's mind.
He remembers the time when he first embraced a respectable
'normality', and started repressing his own 'abnormality'. This is
important, because it is part of what makes for the unity of impact
and the integrity of the film: the replacement of Destiny in Moravia's
story with Marcello's unconscious. He has then built his narrative
structure out of that Freudian premise: things are linked by the

urgings of the unconscious in a chain of association of ideas, fantasy wish-fulfilments and repression. (At a more obvious level, the scene that immediately precedes the murder is one where Marcello recounts to Manganiello a dream in which his wishes are fulfilled and his anxieties allayed.) In shot 14, attention is drawn to the fact that Marcello is in a reverie, daydreaming, by Manganiello's attempt to penetrate it. The camera points straight at Marcello's face in close-up, but through a windscreen that from time to time makes itself more or less obtrusive, while the sound puts us inside the cocoon of the car. It is as though Marcello, in his reverie, and in his conversation with Manganiello, were lying on the couch in the psychoanalyst's studio, and we, the viewers, were gradually penetrating through the windscreen and Marcello's forehead into his psyche. The transition to the reverie, a flashback, is carried out in a characteristic way: gradually. Here it is the music which makes the transition gradual. Elsewhere, as when Marcello gets out of the car, it will be a match cut or a series of them, to the Rolls-Royce of his childhood seduction, and in many cases there are repeated brief entries into a flashback before it is definitely established in the narrative. In the present case, the precision with which the song, its sections and its rhythm are used is an important indication of the care with which the sound editing has been carried out.

15. The interior of an EIAR radio studio. The middle horizontal third of the screen is filled with a window that looks from a dimly lit anteroom into a brightly lit radio studio. Just to the right of the centre of the screen, with his back to the camera, almost in silhouette, as he stands looking through the window into the studio, we see Marcello in three-quarters shot. In the studio, raised up a few feet, three women (just such a trio, the Trio Lescano, was enormously popular at the time in which the film is set) are singing the song in front of a microphone, performing a sort of choreographed swaying and hand-waving to the music. Italo's voice-off: *So you are really determined to go ahead, then?* (his voice slightly suppressing the music). Marcello slightly turns his head to the left.

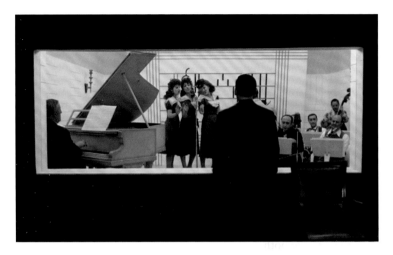

16 and following. Italo, head and shoulders facing the camera almost, seated at a desk: *What do you expect from marriage?* A reverse-angle sequence carries the dialogue. Marcello: *I don't know, a semblance of normality.* Italo: *Ah, normality!* Marcello's voice-off: *Yes. Stability, security. In the morning, when I get dressed, I look at myself in the mirror and my image seems to be different from that of other people.* Italo's voice-off: *But what do you like in Giulia?* Marcello: *I don't know. Maybe it's her body, her sensuality.* Italo's voice-off: *And she?* Marcello: *Every time we're alone together* (laughing) *she jumps on top of me* (folding his arms). Italo's voice-off: *And then?* Marcello: *We end up rolling around on the carpet.* Italo's voice-off: *And the maid with the big tits?* Marcello: *Ha! She's part of the dowry.* Italo, with his hands together on his blotter, which he then moves apart, leaning forward: *So you are getting married and I'm losing my best friend. But I'm … pleased.*

21. The three girls singing at the microphone and swaying; the one in the middle comes forward a little, while the other two turn slightly to one side, as the middle one sings solo part of the song's bridge: *L'amor gioca sempre col cuore l'eterna partita* (slightly *rubato*), 'Love plays its eternal game with the heart'.

The pattern of sound off camera, begun by Manganiello's voice, is continued with the music before the flashback and then Italo's

Marcello at the window into the EIAR studio

voice, and subsequently forms part of the pattern of reverse-angle shots for the dialogue between Italo and Marcello, while the song sung by the girls in the studio is another voice-off. (Somewhere in this reverse-angle sequence an abbreviation is introduced into the song, to adjust its length.) A voice-operated compressor makes the volume of the song decrease when a character speaks, but only for as long as he speaks, with the result that the song returns to the 'foreground' in the spaces between the dialogue.

For the purposes of the narrative, this scene informs the viewer of the nature of Marcello's quest for normality, and thus explains the title of the film. As the episode progresses, the viewer is invited to make an implicit parallel between Marcello's conformism and fascism's search for a stable worldview – and to see the empty and illusory nature of both quests. On a psychoanalytical level, it goes much further. It establishes part of Marcello's neurosis: 'In the morning, when I get dressed …' (shot 18) to '… different from that of other people' (shot 19) are spoken while he puts his hands where his breasts would be if he were a woman, a gesture which is then repressed, as it were, by his tightly folded arms.[37] Italo's 'loss' (of his best friend) can only suggest some kind of 'opposite' to the marriage that Marcello is undertaking. In other words, homosexuality is being suggested as part of Italo's role. The marriage to Giulia is set up straightaway as little more than a formality for Marcello (the interest in the 'maid with the big tits' will be used to further this suggestion in the scene in Giulia's mother's flat – though one is tempted to suspect that these fragments concerning the maid are leftovers from a narrative thread intended to be developed at one point and subsequently dropped).

For the *mise en scène*, the window that separates the studio from the anteroom adds to a list of sheets of glass that both let light through and reflect it, and which help to organise the meanings of the film.[38] Here, the glass separates Marcello from the world of make-believe that the singers represent, and is deliberately made to look like a cinema screen onto which the make-believe world is projected,

to be viewed and desired by the audience sitting in the darkened remainder of the room – it is one of a number of metaphors in the film for not only the physical fact of the cinema image, but also the state of emotional and psychological enthralment it constructs for the viewer (who is in this instance not just Marcello but the radio audience for whom a fascist ideological paradise is being created). In shot 15, we see him looking through the glass, from a dimly lit room into a brightly lit one, with the girls singing 'Who Is Happier Than Me!' and reproducing the clichés of romantic love (shot 21). In fact, in shot 21, *we* become the targeted audience, and this has already been partly set up by the shot over Marcello's shoulder in no. 15. The life he is trying to establish with Giulia has the same status as the show that is going on behind him. The girls are *choreographing* their song to non-existent viewers (a microphone cannot pick up a visual message). The brightness of the light and the dancing of the girls contrast with the darkness and immobility of Marcello, and the effect is to endow the world beyond the pane of glass with greater intensity as an object of desire, corresponding to Marcello's heaven. But it is, in fact, a show, an illusion, and the pane of glass 'says' that. (An entirely similar effect is used when Giulia goes shopping for an evening gown, and goes ecstatic before the brightly lit windows of a Parisian store – one could call it the shop-window effect, and it would then become entirely clear how Bertolucci wishes to suggest that the radio broadcast is bourgeois capitalism's way of 'selling' an ideology to the masses; Marcello is a particularly eager and self-conscious 'buyer' who will, ultimately, see through the product to the reality which it is trying to hide.) Our memory of what we see in shot 15 will enable us to make sense of what we see when Marcello is photographed from a camera position on the other side of the glass (shot 28, below): his face is partly obscured by the reflection of the music stands – his image is partly effaced by the accoutrements of the 'show'. The adjustment to the soundtrack (done while the girls are off camera) allows for the immaculate synchronisation of soundtrack, image and dialogue that follows. First of all, Italo's

lament at the loss of his 'best friend' is glossed by 'Love plays its eternal game with the heart'; secondly (in shot 25, below), Marcello's story and the song end together; while thirdly, the cutaway from the flashback can be against the eight-bar instrumental break in the song (just as the entry into the flashback was).

22. Marcello in the car, as no. 8. On the soundtrack the instruments go into the turnaround of the song, and the camera cuts on the first beat of the next chorus.

Let us jump to shot 25. The camera is looking at the screen again. Italo's voice-off: *It's funny you know, everyone wants to be different from everyone else, and you instead want to be the same as everybody else* (this remark comes from the novel, where it is spoken by Giulia to Marcello). As Italo speaks, Marcello turns 90 degrees to camera left, and walks along the window, with the camera tracking parallel with him, and doesn't exactly reply to Italo's remark; he just launches into a speech which, by virtue of juxtaposition, the viewer takes to be a reply to Italo's remark. As he gets near the edge of the window, he turns and walks in the reverse direction, with the camera tracking along still. Marcello: *Ten years ago my father was in Munich. He told me that often in the evening, after the theatre, he would go with his friends to a bar* (he has now gone beyond the edge of the window to the right, and has a black background. He turns 180 degrees and continues walking, with the camera still tracking in parallel), *and that there was this rather funny lunatic ...* (the girls in the studio are doing a choreographed swaying left and right to the song) *who would be talking about politics. He had become an attraction.* (Turns to retrace his steps left to right.) *People would give him a drink, wind him up, and he would climb onto a table, and make speeches like a raging madman.* (He has now reached the centre of the window, and turns to face Italo behind the camera, with the girls in the background over his shoulder.) *It was Hitler.* As he says 'Hitler', the girls end their song with a visible flourish of their arms to either side of his head. Marcello turns his back on the camera and faces the studio, his hands in his pockets (though we only see as far down as the elbows). The girls file elegantly down from behind the microphone, smiling in the direction of

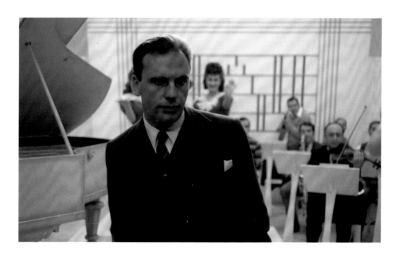

Marcello (i.e. straight ahead, to them), even though it seems clear that they cannot see him through the window, and they turn to camera right to file past the window out of the studio, very close to Marcello, behind his shape in the foreground. The musicians start collecting their instruments and leaving too. A female announcer's voice, off camera, says: *We have broadcast 'Who Is Happier Than Me!' by Cesare Andrea Bixio*, as the girls are filing out. Marcello turns 180 degrees to Italo (i.e. facing the camera, more or less). Announcer's voice-off: *That ends* ...

Shot 22 continues the pattern, which will be maintained throughout the film, of constant returns to the moment of the reverie, so that *only the scenes in Paris* are allowed to have some kind of narrative autonomy. It is true, those Parisian scenes are also, strictly speaking, flashbacks, in relation to the car drive, but they are given the status of 'real' events, whereas the episodes leading up to the honeymoon set in Rome are held at the fantasy level by this continual return to the dreamer, or rememberer. Shot 24 gives us for the first time some idea of the topography of the studio anteroom (though not enough for the orientation of shot 26, below, to be immediately clear on a first viewing). It is characteristic of Bertolucci's technique to

It was Hitler

eschew establishing shots, just as it was for his master, Renoir, too. The *mise en scène* of the anteroom makes it cocoon-like, a place where one confesses to father figures in soft voices and dim light – like the car with Manganiello, and Quadri's study; the Colonel will subsequently take Italo's place.

Shot 25 is very carefully calculated from the point of view of *mise en scène*. The logic Bertolucci intends in the exchange at the beginning may not be entirely clear. Marcello's story appears to be a response to the question of why he wants to be the same as everyone else: people who try to be different are like Hitler. In the logic of the film's narrative, however, Hitler, the 'raging madman', is now the norm which Mussolini's Italian society has adopted, and which Marcello himself is adopting in order to conceal behind it what he fears is his own abnormality. The Italians will shortly be giving Hitler a rapturous welcome on his historic visit to Italy. This very incoherence works to the advantage of what we come to see as Bertolucci's corrosion of social reality: the normality Marcello embraces is depicted as one even Marcello himself sees to be an illusion. The level of connotation may be more easily interpretable than the level of denotation, and this is not unusual with Bertolucci's films, to the extent that he has occasionally been criticised for indulging in *mise en scène* virtuosity at the expense of a profound and well-thought-out surface message. In this shot, however, the moving camera is used to telling effect. Marcello is describing a 'show', that of the *lunatic*, the *raging madman*, Hitler. He does so in front of a seemingly sane 'show', the girls' performance of the song, but the fact that their show has only illusory status is emphasised by the way the moving camera brings to our attention the edge of the window (the shop window, or cinema screen) which contains it. Marcello moves from the bright window to the black wall several times, and the effect is of the bright image appearing and disappearing, drawing attention to its borders. Light going on and off is a leitmotiv throughout the film, and is part of the articulation of the opposition between appearances and reality, an opposition that will include the cinema itself, and this very film.

This will become clearer later, when we discuss the scene in Quadri's study. For the moment, we can say that Marcello describes a show while standing in front of a show, and while being himself part of the show that is the film we are watching. Bertolucci has constructed a sequence which superimposes one social 'illusion' with profound political and historical implications (Hitler's rise to power) onto another (that of Mussolini's idealised projection of fascist Italy) – this scene takes place a month or so before Hitler's visit to Italy in spring 1938. This could hardly be considered indulging in *mise en scène* for its own sake. And perhaps that can help us reach a critical perspective on the film. This scene is not taken from Moravia; it is a poetic cinematic creation of its author, dense and powerful in itself. Whether its coherence in the whole narrative is entirely persuasive is another question. The film assembles a series of these dense and powerful 'poetic images', held together – sometimes very well, sometimes not quite so well – by thematic and narrative links. What it is not is a 'discourse'. It may say lots of things without ultimately saying any one overall thing. And in this it breaks away from political cinema of the time, where discourse, and a coherent 'position', were critical. This can help us to understand Bertolucci when he says that he moved from demanding penance from his viewers to wanting a dialogue, to penetrate directly to their emotions and to give pleasure to his audiences.

The other constant thread in his self-account is his background in poetry. The two fit together: as he says time and time again, his job is not to explain a meaning – the film is the film; it is an object, an artefact, not a 'discourse'. The density of connotation and the corrosion of the cognitive status of the cinematic image is achieved by Bertolucci through a process of superimposition, a process he will use time and time again in this and in all his films. The very fact that he uses sound often non-synchronously is already a device of superimposition (a famous example in an early film is his use of Verdi's *Macbeth* in the opera house scene in *Prima della rivoluzione*). What he is referring to when in interviews he talks about the moving

camera being more than a recording machine is precisely this ability
it has to move the attention of the spectator from one thing to
another, and superimpose one visual stimulus over another, one layer
of meaning over another. To return to shot 25, Marcello's story has
its punchline, which resolves the mystery in it – the identity of the
lunatic. This punchline is delivered simultaneously with the finale of
the show in the background – the girls' song. They then approach to
within inches of Marcello's face (which is looking at them), but
without either of the two parties acknowledging the other's presence:
the window lets light through in one direction and reflects in the
other; it is the barrier between illusion and the 'something else' that
Marcello represents and wishes to escape.

26. Italo comes over to stand beside Marcello, between him and the edge of the
window. Meanwhile, the announcer's voice-off continues: ... *our programme of
light music with the Arcangeli Orchestra. You heard Silvana Fioresi, Oscar Carboni,
Lina Termini and the Trio delle Rondinelle*, after which, immediately, there begins
the sound of a bird-call imitated (which is the station identification signal of
EIAR), though we do not yet see the source of this sound.

The song was the work of a composer who was very popular at the
time. The performers listed by the announcer existed as famous and
popular radio entertainers, albeit a year or so later, rather than in
1938. Rather than there being a historical 'Orchestra Arcangeli'
(Orchestra of the Archangels), there was a singer called Maria Pia
Arcangeli, who joined EIAR in 1940. The Trio delle Rondinelle
alludes to the Trio Lescano who were enormously popular at the
time, and who are the performers of the song which ends the film
(though be warned that the US Paramount DVD has cut the end titles
and replaced them with other business).

27. Bird-calls on the soundtrack. The camera is looking directly at the wall
between the studio and the anteroom, with the right-hand edge of the
window going down the centre of the screen, so that the left-hand portion of

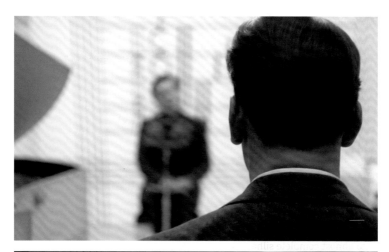

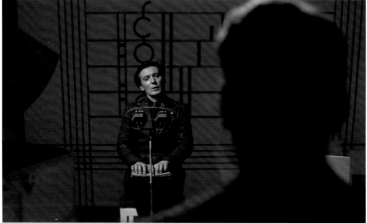

the screen contains the image of the brightly lit studio, with a man bending slightly towards a microphone, whistling into it the bird-calls, while the right-hand portion of the screen is more or less masked by the dark wall of the anteroom. The camera holds this image for four and a half seconds, and then begins a slow track to camera left, bringing into view the following: firstly, Italo, seated on a stool in the studio, brightly lit and in focus; then

Marcello and Italo I; Marcello and Italo II

Marcello's head and shoulders from behind and out of focus, as he looks into the studio. As the track proceeds, the camera rack-focuses from Italo in the studio to Marcello in the anteroom, and as this happens, the image of Marcello's back covers the image of Italo, which is now out of focus. Here, the announcer's voice-off says: *The Mystical Nature of an Alliance. A Talk by Italo Montanari*; at which point Italo starts speaking. Meanwhile, the track has continued, and Italo's out-of-focus image has reappeared from behind Marcello's figure, whereupon the track stops, leaving the frame filled with a large, dark, focused image of Marcello's head and collar at the right, and a bright, unfocused, almost full image of Italo in the studio. This is the point at which Italo starts to speak, and as he does so, the lights in the studio go down, until the room is lit in a dim blue-green light, with highlights on Italo's head and on his hands, which are holding papers on his knee. Marcello goes into almost complete silhouette, with a little highlight on his hair.
The camera rack-focuses from Marcello to Italo, who is reading his script from braille sheets with his hands and speaking into a large microphone in front of his face, his head tilted so that he seems to be looking a little up towards the ceiling roughly in Marcello's direction. Italo, in a declamatory tone: *Italy and Germany: the foundations on which two civilisations are built. Over the course of the centuries each encounter between them signals …*

The radio studio is broadcasting, and we get to see the source of all the sounds that are broadcast from the studio. The effect of this is to make it clear that while we are present in the studio, what we are hearing is in fact what is broadcast; we do not see the source of what is broadcast from other studios. We think this will be the case for the sound of the bird-call station identification signal at the end of shot 26, but then shot 27 shows us the source of the sound. This has comic overtones for an Italian. It is a bit like being shown a man with a penny whistle making the six beeps of the BBC time signal.
With reference to shot 15, I suggested that behind the window lay Marcello's 'heaven', and here the voice of the announcer identifies the musicians as 'Archangels'. At the end of the film, Bertolucci will use a similar code to express Marcello's striving for an ideal, when he

photographs the Clericis' young daughter saying her prayers against wallpaper that is sky-blue with clouds painted on it. Italo's move from his desk to the window emphasises his blindness. Shot 26 leaves him beside Marcello in the left-hand side of the frame, with the edge of the window to his right, beyond which the right-hand side of the frame is black. In other words, we see Italo, together with Marcello, against the window, but *this side* of it. In the next shot, shot 27, he will be on *the other side* of the window, in Marcello's fantasy ideal world, *without* our having seen him move from one side to the other – he simply 'appears' on the 'fantasy-projection screen', as it were. But first, the bird-call imitator: an illusion which we see through. If material reality in Plato's scheme is but the shadow of an imitation (as we are told in the scene in Quadri's study, of which more later), then this image is the illustration of it. The edge of the studio window goes down the centre of the screen, and the camera holds this image for a deliberate period. In an Antonioni film, this would be a device for masking the frame so as to produce an aspect ratio that was higher than it was wide, and so appropriate for a portrait. This is not the purpose of this shot. Marcello stands on the left of Italo, both are looking at the window, and both hear the bird-call. In the beginning

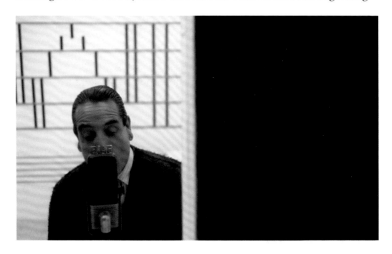

EIAR station identification signal

of shot 27, Marcello sees the brightly lit illusion on the left half of the screen, and Italo sees the 'nothing' that is on the right side of the screen. It is a shot that *functions* as an authorial comment or, perhaps, more correctly, as a poetic device for judging the content of Italo's speech. As the camera moves, it produces a superimposition of the image of Marcello over that of Italo. The double rack-focusing invites the viewer to keep looking from one to the other. Devices like this have become a characteristic of Bertolucci's cinema, and a short digression on this point is in order.

Similar devices are frequently used in connection with the relations between father and son, or men and their father figures. They are used when Fabrizio and Cesare are sitting in front of each other on park benches in *Prima della rivoluzione*. The most famous case occurs in *Strategia del ragno* (famous partly because a still from the sequence is evidently the standard publicity handout for the film). At the end of a long tracking shot, the camera rejoins Athos junior, who has moved ahead and is looking at a bust of his father; as he moves, his image covers the bust; he then moves past the bust, and the camera tracks to one side until the bust covers his image in the background.

The other interesting example of superimposition in *Il conformista* occurs when Manganiello is loudly addressing an invisible Marcello in the Square Louis XVI in Paris. An elderly Parisian lady is outraged that he should think Parisian birds spoke Italian. Manganiello is eventually reduced to singing a song under his breath in frustration, and sprawls on a bench, whereupon the camera tracks to one side so that a tree in the foreground totally obscures his image, though we continue to hear his voice. This scene is amusing, and is probably partly a joke. But it is more than that. Marcello the 'normal' married man is an illusion, and he is becoming increasingly reluctant to have Quadri killed. It is therefore entirely appropriate that he is invisible to Manganiello. The latter is, himself, a manifestation of a fantasy superego ideal which is in turn an illusion. The tree merely makes the point. As the tree is made to erase Manganiello, he starts singing a song sung by the Militia of the Republic of Salò, Mussolini's

wartime Fascist Republic (the monarchy was sheltering behind the Allied lines in 1943–4), whose words ('Women no longer love us/Because we wear black shirts') allude to the collapse of fascism, in which women, like everyone else, have opportunistically gone over to the other side, so that the only romance remaining is with death. To have the song sung in 1938 is an anachronism, but an effective one, politically evoking the void that lies behind Manganiello's hyper-virile activism. Moreover, the superimposition of the tree on Manganiello suggests an identification: he has the solidity, the ideological unsubtlety, the down-to-earthness and the phallocentrism of a tree: the scene in the Chinese restaurant kitchen where he tells Marcello that when he feels himself failing he lights up a *toscano* (Italian cheroot, another phallic symbol) and tells himself to get on with it is an illustration of this strength in stupidity. In this Parisian square, his only resource for persuading Marcello to go through with the murder is to repeat the slogan barked by the agent Raoul in Ventimiglia: *The action must be swift and decisive*. In Manganiello, Bertolucci portrays the nationalist-fascist ideology of mindless, virile, violent action, in which the highest state of humanity approaches that of the machine.

But trees also hide, and it is from behind trees that the assassins appear to murder Quadri. Superimposition for the purpose of hiding is what repression is about, and is what Marcello is trying to do with his marriage and with the murder of Quadri. His marriage serves partly to hide his homosexuality, the murder of Quadri is supposed to superimpose itself on the murder of Lino and so expunge it. Marcello is frequently covering women's bodies, to hide their nakedness and the erotic associations that go with it (he covers Giulia's naked body in the opening sequence shot, he covers his mother's thighs, and he wants Anna and Giulia's dance in Joinville suppressed). As Giulia starts to tell him of her childhood sex life with Perpuzio, Marcello pulls down the blind on the compartment window, as though to hide something he does not want to see. The 'illusion' that is Marcello the fascist secret agent is playfully illustrated when at Ventimiglia he walks behind a painting of the sea,

and the camera dissolves to the real seafront behind it in which Marcello is present (immediately afterwards, the sailors guess straightaway that he is an official, and salute him). In this shot, Bertolucci is quoting, or is playfully superimposing on his film, Magritte's 1947 surrealist painting *La Belle Captive*. That whole sequence opens with an entirely arbitrary and almost surreal figure in close-up whistling the tune to the song I have just described Manganiello singing in Paris.

In the scene where Quadri is murdered, Bertolucci 'superimposes' the scene of the assassination of Caesar from Joseph L. Mankiewicz's 1953 film of Shakespeare's *Julius Caesar* (it is not that Bertolucci shoots the assassination in the same way, but rather that the patterned rhythm of alternating stabbers is reminiscent of the earlier film, as is the sense of scandal communicated to the viewer by the desecration of the paternal figure). This case of cinematic quotation is, however, more complex than that, because Bertolucci is, by allusion, quoting himself. The killing of the anti-fascist hero, Athos senior, in *Strategia del ragno* is full of allusion to the killing of Caesar in Shakespeare's tragedy. Athos junior must acquiesce in the killing of his father, must become, despite himself, a conspirator in his father's 'martyrdom'. Marcello is in a similar position with regard to his father figure, Quadri. A list of just some of the textual superimpositions that result from that sequence of the stabbing of Quadri would have to include Plutarch and Tacitus, Shakespeare, Mankiewicz, Borges, *Strategia* (adapted from a Borges story), Moravia's *Il conformista* – as well as a clear reference in the whole episode to Truffaut's 1960 *Tirez sur le pianiste*, and the assassination of Carlo Rosselli. There are others …

A different kind of superimposition is that of thematic superimposition, when a number of themes come together in one episode. An example occurs at the house of Marcello's mother. The rolled camera sequence of Manganiello 'tailing' Marcello introduces Manganiello in a 'crime-genre' vein, and we later learn that he is a fascist thug. He is then used to suppress the mysterious

and ambiguous Alberi, thereby metaphorically enacting Marcello's Freudian 'repression' of homosexuality and murder. Marcello tells Manganiello that the Japanese name Ki (pronounced like the English word 'key') translates into Italian as *alberi*, meaning, in English, 'trees'. The word *chi* (pronounced 'key') in Italian means 'who?' – and much punning play is made on this. We know 'who' Ki is in Marcello's psyche: Lino, that other chauffeur. The suppression of Alberi is the suppression of Marcello's mother's libido, and in turn of his own – in other words, suppression or concealment of his own erotic impulses. (Incidentally, Quadri's assassins will appear from behind *alberi*, and an *albero* will obscure Manganiello in the park in Paris.) His mother deserves this suppression for expressing the wish that Marcello's father should die. The father is the superego (indeed, the cut from the soft, warm-coloured ambience of the mother's villa and its windblown leaves to the hard angles and the dazzling white of the father's abode is a classic case of what Eisenstein would call the creation of meaning through collision in tonal montage). The *mise en scène* of the villa juxtaposed with that of the asylum creates the opposition that signifies id and superego, narcissistic pleasure-principle and guilt deriving from setting up in the psyche an

The *id*. Marcello's mother's house: Manganiello removes Alberi's cigar

identification with the lost paternal libido object. The fact that
Marcello's father's straitjacket is black is the superimposition of
fascist blackshirt onto medical straitjacket (which is normally white).
Finally, as we shall see in the scene in Quadri's study, the cinematic
image is the superimposition of a shadow onto a screen that is not
what the shadow would be. This brings us back from the digression,

The *superego*. The father's asylum; blackshirt straitjacket

because Bertolucci casts the problem of illusion and reality in terms of seeing. Marcello sees awry. Italo does not see at all, and yet he is the ideological guide. His confident, declamatory tone is marred in shot 27 by the pause he needs to take in order to find his place in his braille script with his fingers. His speech, 'The Mystical Nature of an Alliance', attempts to suggest a predestined union between the Italians and the Hitler whom we have just heard described (to no protest from Italo) as a *lunatic*, a *raging madman*. Once he is on the other side of the window, however, Italo becomes part of Italian society's fantasised ideal of 'normality', and so exactly the 'norm' that Marcello is trying to hide behind (despite openly betraying, by falling asleep, the fact that he does not believe a word of the drivel that Italo is spouting).

28. From its position in the studio not far from Italo, the camera photographs Marcello through the window. Marcello's head and trunk are positioned about two-thirds of the way to the right of the frame, and he is leaning with his hands on the windowsill. Behind him and to his left can be seen the lamp on the desk at which Italo had been seated at the beginning of the scene. Reflected in the glass of the window, to camera left of Marcello's image, is the image of Italo, and his hands reading the braille, and also down in the bottom left-hand corner of the frame, the reflection of the music stands that the musicians had been reading from. Italo: ... *a turning point* ... (here he pauses to raise the top sheet of paper against his chest, and searches with his hands for the first line of the next sheet – all of which we see in reflection) ... *in the course of history. Today, when* ... (Marcello starts to sit down in a chair that lies out of sight behind the wall beneath the bottom left-hand corner of the frame, turning to profile facing camera right as he lowers himself into the seat, his head coming into the space in the window occupied by the reflections of the music stands in the studio) ... *by virtue of their leaders, our two peoples find their true virtues deep inside them, now, in this retrieval they rediscover at the same time* ... (Marcello, now seated facing camera right, turns his head – not quite all of which is visible – to look through the window at Italo) ... *the reciprocal neglected similarities previously forgotten: what Goebbels calls* ...

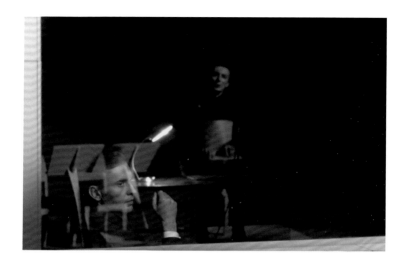

In the ensuing shots, Italo's speech continues: ... *the Prussian side of Benito Mussolini, and what for us is the Latin side of Hitler. Italy and Germany! Heralds of two great anti-parliamentary and anti-democratic revolutions!* Bertolucci actually makes the pane of glass the protagonist of his shot: we see its transparent and its reflective qualities simultaneously. It would be easy to say at this point that Italo is given the connotation of illusion by virtue of the fact that his image is merely a reflection, whereas Marcello's image comes through the windowpane. But as Marcello sits down, the objects pertaining to the 'show' we have just seen, the music stands, partly efface his image. This is deliberate, because the studio from which Italo is broadcasting is now dimly lit, with just the odd highlight, particularly on Italo. In other words, Bertolucci chose to light the music stands in such a way that they would interfere with the image of Marcello. The substance of Marcello and Italo is subjected to a 'critique' of their images that runs parallel to a speech on the soundtrack that expresses empty idealist rhetorical conceits, delivered by a man who can see neither what is real nor what is illusory. In the speech, Italo claims that the meeting of Fascism and

The transparency and reflection of screens

Nazism produces a synthesis, 'the true virtues deep inside them' (never really precisely defined anywhere in the speech); and this quest for a solid, profound 'norm' is equivalent to Marcello's quest. The juxtaposition of Marcello with the reflection of Italo equates the two. The plane of their meeting is the pane of glass of the shop window/cinema screen. The message of the film is quite clear: Marcello is chasing an illusion. It is, of course, a message ideally suited to cinema, which is itself the product of an illusion. In fact, in no time at all Marcello discovers that his wife's normality is illusory. By the same token, fascism is an illusion – the projection of values by a bourgeoisie seeking an anchor in a reality that is nothing more than an ideological construct. All of this is made explicit in the scene in Quadri's study, and a digression on that scene is in order here.

The episode begins in the Hotel D'Orsay, where seemingly insignificant details are loaded with meaning, as Giulia paces out the size of the room while Marcello sits on the bed. He is seated in the position we saw him in at the very beginning of the film, and when, a minute or so later, he speaks on the telephone, the repetition is complete. Bertolucci has everywhere dosed the complexity of his construction with the symmetry of repetition. In this case, the repetition in the *fabula* (or *plot* of the film – events as they are presented to the viewer) constitutes an inversion of the *syuzhet* (or *story* – events as they unfolded in time). Giulia is treated throughout the film with the procedures of comedy: here, checking whether they are getting their money's worth; earlier, in the train, rhetorically declaring herself unworthy of her husband; shortly, expressing wonderment at the beauties of Paris embodied by the station and the hotel, and fantasising about romantic suicides from the Eiffel Tower, which Marcello exploits to permit him to go off with another woman (Bertolucci could have chosen from among a number of ways of treating that plot element); later, in the restaurant and the dance hall, gloriously tipsy.

She is not the only element of comedy in the film. In a work made up of a mosaic of jewel-like fragments, one of the ways

Bertolucci (the sole scriptwriter) joins the pieces together is with a procedure of verbal games. In Giulia's mother's house, it pivots on the word 'secret' (Marcello on the topic of the honeymoon: *It's a secret*. Giulia: *A secret?* Her mother enters from the corridor: *A secret! I adore secrets!*). And then, in the garden of Marcello's mother's house, there is, as we have seen, the play on the chauffeur's name (Ki/*chi*/who/*alberi*/trees). And shortly, in the Quadris' apartment, Anna will ask Giulia: *I am curious ...* (about whether you made love before you got married), whereupon her husband will ask Marcello: *I am curious ...* (about the motive for your visit).

Verbal devices abound in the film: such as the procedure of beginning a scene with an imperative on the soundtrack (*Music!* at the stag party, *Listen!* on the train, *Attention!* for the epilogue).

Characters names are playful: Manganiello echoes the 'cudgel' or *manganello* that fascist thugs used for beating up socialists and trade unionists; Perpuzio is the Italian word for foreskin (*prepuzio* or *perpuzio*); the orchestra in the radio studio consists of archangels; Marcello's fascist ideologue friend has a patriotic name, Italo. Quotations abound too, as we shall see later. In the hotel bedroom scene, Giulia finds the room to be 54 square metres (in Italian, *metri quadri*), whereupon Marcello says: *Yes, Quadri* (is his name ...). Giulia asks him first: *Who are you calling?*, to which Marcello replies: *To a little hunchback*, which in Italian is *A un gobetto*. One of Italy's most distinguished anti-fascist intellectuals, who died young on his honeymoon in Paris soon after a fascist beating, was Piero Gobetti, a figure whom, by this pun, Bertolucci is superimposing on first Quadri and then Carlo Rosselli, Moravia's cousin, to whose murder the film alludes. Marcello asks for the telephone number Médicis 15-37, and in the ensuing telephone conversation is invited to the Quadris' apartment at rue St Jacques 17. These are the address and telephone number of Jean-Luc Godard, the *nouvelle vague* film-maker who was a model and father figure for Bertolucci as a director, just as his own father, Attilio, and a family friend, Pier Paolo Pasolini, were for him as a poet. When Bertolucci

begins *Il conformista* with a flashing red cinema sign for Renoir's
La Vie est à nous (a Communist Party-funded film to support the
election of the *Front Populaire* in 1936), he is implicitly rejecting
the austere relationship that Godard had by then set up between the
film-maker and his audience.

When Marcello speaks to Quadri on the telephone, he says: ...
E voi ... (corrects himself) ... *Lei mi disse* (he starts with the form of
polite address, *voi*, imposed by the fascist regime in preference to the
previously universal *lei* form, and then corrects himself) ... *You said
to me, I remember it well: 'For me the time for reflection is over, now
begins the time for action'*. The sense of the remark comes from
Moravia's novel, where Quadri says, 'I've decided to pass from
thought to action'. But Bertolucci's phrasing inverts the opening of
Godard's first political film, *Le Petit Soldat* (1963), about a right-
wing conspirator whose his girlfriend works for the FLN, who is
ordered to murder a FLN activist to prove that he is not a double
agent. Godard's film begins with a voiceover: *For me the time for
action is over. I've aged. The time for reflection begins.*

Giulia witters on about Quadri probably being a useless
intellectual. So says Perpuzio, her sexually predatory uncle, who:
Anyway, is the one who sent the anonymous letter (referring to the
letter that was read out at her mother's house). Here, we cut away to
Manganiello in the street outside the hotel, accompanied by his
rhythmic music. Immediately we cut back to Marcello, who barks
violently at her: *Piantala!* (*Stop it!*). The phone rings and he knows it
is Manganiello – again violently to Giulia: *Ma rispondi!* (*Pick it up!*).
The introduction to Quadri, and to Marcello's love/attachment to
this father figure (ironically belittled by another 'fatherly' sexual
rival, 'uncle' Perpuzio), is paired with his reluctance to have to
destroy him (Quadri) in order to conceal a fundamental part of
himself (Manganiello standing for the crude vulgarity of his chosen
disguise), evoked here by Bertolucci with this sudden violent
explosion of rage. The only other time Marcello is shown having so
powerful an emotional response is when he is made to denounce Lino

and Italo at the end of the film, when the flight from his inner demons described by the film has come full circle.

The pattern of repetition continues outside the hotel with the long tracking crane shot (almost exactly one minute long), from close to the headlights of Manganiello's car, to Marcello and Giulia going to their taxi (which is in the same position on the screen as Manganiello's car was at the beginning of the film) and driving off. This further repeat, or memory, of what we saw at the beginning of the film contributes to the gradual build-up of meaning and memory with which the car drive in the present is loaded, while the comedy of the dismissal of Manganiello is carried by the soundtrack which plays the 'Manganiello' musical theme.

Paris is presented as the opposite of Rome, and so the décor of Quadri's apartment contrasts with the fascist locations in Rome: potted plants, wood, leather – natural colours, particularly brown as opposed to the white of Rome (the books in the bookcases in the conservatory are library books, with library bindings and shelf labels). Interestingly, the location used for Quadri's home was a turn-of-the-century apartment in Rome. The strange circular arch leading from the main apartment to the conservatory offers scope for striking pictorial compositions. Comically, Giulia doesn't notice how Anna keeps her back to Marcello and refuses to offer him coffee. Quadri's office is bare, all made of wood, while the smoke from a cigarette left in an ashtray serves to *reveal* light, but also to *evoke* the fire of Plato's cave.

As Marcello starts to describe the myth of the cave, the camera very, very slowly descends from a high to a low position, simultaneously tilting upwards, bringing in the tall window behind the desk, revealing the church outside, with Marcello a tall figure seen from below in the foreground. He starts miming with his hand the passage of the statues in Plato's myth of the cave, and the camera begins to rise and pull in. There is a cutaway to a brief shot of Quadri against the window, followed by a full shot of Marcello giving a fascist salute, with his shadow on the wall behind him. He looks up at his hand and quickly withdraws it, making explicit for the viewer

(*Next page*) Plato's cave

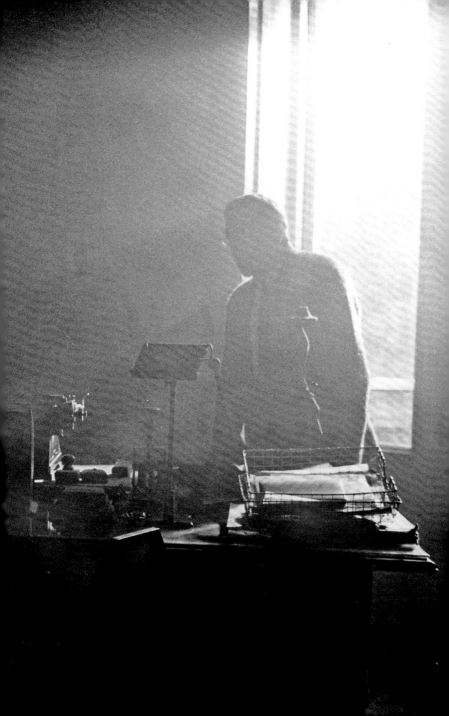

the reference. After a sequence of reverse-angle close-ups of Marcello and Quadri (Quadri in shadow, almost a silhouette, Marcello lit), Marcello turns to the wall bearing his shadow, as the dialogue reaches the words '*the shadows of things*' (Quadri's critique of fascism is an idealist one, characteristic of bourgeois anti-fascist intellectuals). When Quadri says of Plato's slaves: *They would mistake for reality the shadows of reality*, Bertolucci is repeating, on a verbal and conceptual level, the scene in front of the EIAR studio window, giving a sort of didactic gloss on that earlier scene. Plato's parable describes cinema, with the audience, like the slaves, gazing at shadows of imitations of reality.

The ensuing dialogue goes as follows. Quadri: *That was your thesis* [Plato's myth of the cave]. *Did you complete it?* Marcello: *No. You left and I did another one.* Quadri: *I'm really sorry, Clerici. I had great faith in you. In all of you.* Marcello: *No, I don't believe it. If it were true, you would never have left.* The theme here is abandonment by the father; the loss of his support and approval. One could wonder whether this might not be a thematic thread running through Bertolucci's cinema for many years. It is not quite

Marcello illustrates Plato in more ways than one

the same as the competitive Freudian/oedipal killing of the father that the director openly and repeatedly declares, but rather anger, and a punishment of the father for a betrayal and an abandonment, or even aggression as an index of the uncrossable distance between master and pupil, father figure and son – the strength of the anger being a measure of the desire to cross the distance, and of the love. Later in the narrative, the filming of Quadri's killing carries connotations of an element of punishment, rather than mere elimination. On one level of the film, Quadri is a father figure, married to the woman with whom Marcello is in love (Anna embodies exactly the opposite of what Marcello is marrying in Giulia, and is, in her turn, a projection of a fantasy-ideal, as is illustrated by the fact that the actress who plays her, Dominique Sanda, plays two other fantasy-projection women in the film). On another level, Quadri-as-Godard is also Bertolucci's artistic model, who must be discarded if Bertolucci is to fulfil his own identity as an artist. Godard's Brechtian quest has been to engage the viewer in a discussion of the nature, status and meaning of the film image, and to teach the viewer not to mistake it for reality. Bertolucci's preference for poetic expression and for giving pleasure, not just to an elite politically committed audience but to a broad cinemagoing public (he believes that to be his duty as a film-maker), makes him reluctant to follow Godard completely down that path. (As I sit writing this book, I can't help feeling that he is nevertheless demanding a lot from his broad cinemagoing public.) The metaphor of vision is sustained to the end of the film. When Marcello discovers that his rejection or denial (his killing) of Quadri was unnecessary, he denies the opposite father figure, Italo, who is appropriately carried off by the 'people' (now truly virtuous) whom Italo still cannot see.

As though he had touched on something so delicate that a distraction was needed, Bertolucci cuts to the women at the duplicating machine, playing a sort of erotic game: *Più forte! più forte! (Faster! Faster!)* – a cutaway insert that keeps alive the parallel subplot of Anna's lesbianism. Back to the study. Quadri: *At the point we had reached, there was no longer any choice. All we could do was*

emigrate. … We wanted people to understand the historical significance of our anger and our struggle … Marcello: *Fine words! You left, and I became a fascist.* (But we know from so many indications that he hasn't really become fascist. He is uttering this as though punishing Quadri for his abandonment.) Quadri senses this: *Excuse me, Clerici, but a convinced fascist doesn't talk like that*, and he opens the shutters. The camera cuts, not to Marcello but to the blank wall and to his shadow, which disappears. The film-makers have shot the scene with two sources of lighting, one inside the room and the other outside the window behind Quadri's desk. When Marcello closes the window on the opposite wall, the lighting *inside* the room is extinguished, leaving the light outside the window to act as the projector in a cinema. It is enough for the house lights in the auditorium to come on for the fantasy on the screen to disappear.

There follows a moment of stasis in the film. Marcello finds himself alone in the hall of the apartment, Quadri is answering the phone in French off screen, while the two women are talking in a small room, listening to a gramophone, with Anna reciting a poem by Apollinaire and Giulia smoking a joint. Anna asks her: *One lover? Just one?* which functions on one level as yet another reference to Perpuzio, while at the same time picking up the question she had asked Giulia before: *I am curious …* (as though no time had passed in the film). We see down the corridor to Marcello approaching them in their room. Anna sees him (looking into the camera, as she will do later in the lesbian scene in the hotel), rises, winds up the gramophone and says in a cold tone to Giulia: *Wait for me, I'll be back in a minute*. The winding up of the gramophone in this lesbian scene matches the male prostitute winding up his gramophone at the end of the film (see p. 77), yet another of those 'reminiscences' with which Bertolucci continually prompts his viewer.

Rather than return from our digression to the moment in the EIAR radio studio where we left Marcello and Italo, I should like to jump to his introduction to the Minister, who must approve his enrolment in the fascist political police. Bertolucci and Ferdinando

Scarfiotti, the production designer or art director, used as a location for the fascist ministry buildings which had not historically been used as government departments at all, but the partly ceremonial Palazzo dei Congressi, built from 1938 onwards for the 1942 Expo. In the editing, Bertolucci and Arcalli make no effort to assemble a coherent sense of space in this location, but fragment the representation for the

Having seen Marcello observing her, Anna winds up the gramophone; Anna seducing Giulia and looking at Marcello observing her

poetic purposes of expressing a lack of proportion between the rhetorical architectural spaces and the human beings that inhabit them. For example, Bertolucci shoots Marcello entering the building with a downward swooping movement of the camera as he comes down the steps from the entrance to the big hall, panning right and swooping back up towards the high ceiling as Marcello goes up to the desk and then walks past it over to the far corner of the hall. Arcalli takes this exquisite shot, cuts it in the middle, and puts the two halves in reversed order in different parts of the narrative of the scene! Unfortunately, we have space to look closely at only a small selection of sequences from this section of the film.

43. Close-up of a tabletop across the top of the frame, with a woman's calf and shoe swinging down from the middle, and a seated man's leg on the left of the frame. The camera is shooting under the table. A woman's whisper: *Do it again!*

44. The screen is dark at either side, becoming clearer to the centre, where grey curtains can be seen. A hand appears from behind the curtains, pulls one aside, Marcello looks out, catches sight of something near the camera and looks. (This is a reverse-angle shot relative to no. 43; the viewer assumes he is looking at the table and the girl.)

45. Extreme close-up of the girl's face from Marcello's angle, in profile looking to screen left; she turns, chuckling, and looks in the direction of the camera.

46. Reverse angle of Marcello's face through the curtains, which withdraws with an expression of disgust.

47. Reverse angle, this time showing the tabletop through the middle of the frame, the girl seated with one leg raised on the table, the other dangling down, leaning back on her arms, facing the man seated to her left behind the table. The girl swivels round to put her head to the left of the man, and to lie on her back. The man (the Minister) puts his arms around her and buries his head in her bosom. The camera does a very fast zoom back to a very long

shot of the desk at one end of a huge room, the perspective enhanced by a strip of black carpet on the white marble leading from the camera to the desk. On the wall high above the desk and behind it is an eagle, and there are busts on pedestals at either side of the desk.

48. Same as no. 44. Marcello withdraws and shuts the curtain.

The Minister and his mistress (Dominique Sanda) before and after the zoom

The stylistic device of proceeding from detail shot (43) to
establishing shot (at the end of the fast zoom in no. 47) is motivated
by the alienation which Marcello is made to feel in discovering that
the monumental 'norm' of the ministry is tainted. It also serves
another purpose, which is to superimpose religious imagery, and the
connotations of sacredness that go with it, onto the Minister's office.
At the end of the zoom, we have an image of what might be an altar
at the end of a long nave. The girl, and the Minister fondling her, thus
become images of sacrilegious profanation.

Shots 42–8 are a film version of an episode in Moravia's novel.
What Bertolucci has added is the face of Sanda (here playing one of
the three women who represent projections of his fantasy: Anna,
Quadri's wife and the prostitute in Ventimiglia), the way she looks at
Marcello and the intimacy of their exchanged glance. However, this is
not so much a 'real' intimacy as an event in Marcello's psyche. We see
in shot 45 a large, extreme close-up of Sanda's smiling face. It is part
of a series of reverse angles, which leads us to attribute the point of
view to Marcello; we think that this close, smiling face is what he
sees, and for a moment identify with his pleasurable perspective.
But the zoom in shot 47 reveals to us that Marcello is a very long way
from Sanda, and that she must be no more than a tiny figure in the
distance. The zoom back asserts a sort of 'reality' which puts
Marcello's fantasy into its context, and endows it with an aura of
worship. It also repeats the point being made about the relationship
of people to environment.

49. A large hall, the camera looking at one of its walls, with a large staircase
slanting across the top left-hand corner of the frame. Down on the right is a
large door with a massive marble frame, making it seem two or three times
the height of a man, from where the tiny figure of Marcello appears, and
walks towards the camera. Two men walk across the frame from right to left,
and left to right, crossing past each other on Marcello's plane, and bearing a
statue of an eagle and a bust respectively; both of them are dwarfed by the
objects they carry and appear very small in this large space. Marcello turns

90 degrees and walks towards the left, while a man descends the stairs from the top of the frame, stops when he gets to the left-hand edge of the frame, looks down at Marcello and calls: *Clerici! Clerici!* Marcello cannot see him, and retraces his steps towards the extreme bottom right of the frame, turning to look up at the man, and backing closer to the edge of the picture.

Marcello, taking his hat off: *Yes sir, I'm ready.* The Colonel: *I'll have them tell the Secretary. The Minister is waiting for us.* The speakers, two tiny figures in a vast architectural space, are positioned at the extreme opposite corners of the frame during this exchange. There is a conventional hierarchy to the film image on the screen: what is large and is in the centre of the screen is important, while what is small and on the periphery is unimportant. This shot exploits that code very effectively. We are left with an image of Marcello as a figure extremely alienated in his 'chosen' environment. This is in part achieved by having made us superimpose the unconscious level at which Marcello is seeking peace in fascism onto the interpretation of fascism as an inhuman, bombastic rhetoric.

50. The point of view is the same as at the end of the zoom in shot 47. The Colonel, Secretary and Marcello are walking down the strip of carpet towards the Minister's desk. The camera is tracking forward, and the

The Colonel and Marcello at the edges of the frame

Secretary, walking ahead, looks back at the camera over his left shoulder and asks Marcello (the camera): *Is this the first time you have met the Minister?*

51. Reverse angle relative to shot 50 of Marcello's head and shoulders, with the curtains in the background. Marcello: Yes. Voice-off of the Colonel, to which Marcello responds by looking to camera right: *When I explained to him your plan, he immediately said superb!* (Tracking back.)

52. Still tracking, this time forwards again, for a reverse-angle shot of the Colonel from Marcello's point of view. The Colonel is positioned to the left and front, looking back at the camera/Marcello over his right shoulder: *… To get close to Quadri, win his confidence, infiltrate his organisation in order to find out who are his contacts here in …*

53. All three men viewed from behind by the camera, which is still tracking forwards behind them. The Colonel and the Secretary keep looking back at Marcello, who is walking a pace behind them and between the two men. Colonel: *… Italy.* Secretary: *Yes indeed, superb.* (His voice is not acoustically appropriate in the context of the room, more like a muttered voiceover, said with great relish, but unreal in its relation to the image – this tonal quality persists throughout this shot.) Colonel: *And what really matters, unprompted!* Secretary: *Indeed, voluntary!* (at this point logical syntax disappears, and the utterances are like a montage of exclamations). Colonel: *Opera Volontaria* ('Voluntary Work'). Secretary: *Repressione Antifascismo* ('Anti-fascist Repression').

The hushed tones enhance the reverential atmosphere referred to in connection with shot 47. The sense of unreality that was achieved visually in shot 50 is reproduced on the soundtrack in shot 53, as the utterances degenerate into slogans, gradually shedding any conversational syntax. I have used initial capital letters in the last two extracts of dialogue because together they make '*Opera Volontaria Repressione Antifascismo*', the historical title of the fascist political police, OVRA, which Marcello is joining. Bertolucci has added

another layer of connotation by making shots 50–53 an unmistakable quotation from Fellini's *8½* (1963), both in the sound and the *mise en scène*: the conspiratorial voiceover effect, the tracking subjective camera, the 'acolytes' preceding Marcello while turning back to address him. In *8½*, Guido Anselmi was being taken to speak to the Cardinal. In *Il conformista*, it further enhances the religious connotations carried by what Bertolucci represents as

Marcello is introduced to the Minister; Guido Anselmi is introduced to the Cardinal in Fellini's film *8½*

fascism's liturgy, while counting on the viewer to remember that in Fellini's film the sequence served to unmask the emptiness of the revered institutional figure.

The woman on the desk in shot 45 is playing, and her smile is both inviting and playful. The fornication on the 'altar' of the regime is playful in its desecration. In play, what is potentially serious is treated without anxiety, and this is precisely what is depicted as impossible for Marcello. In the Chinese restaurant, Giulia remarks that he never laughs (to which he responds with anger), and Quadri says that he is 'too serious', and that such people are never really serious. Bertolucci depicts sexual encounters in the film as having a playful quality about them – with the important reservation that Marcello's role is always anomalous: he is never playful, or if he is, then there is something sinister about it. His encounter as a boy with Lino is playful, until a certain point, and the shooting results from playing with the gun. Giulia sees sex in terms of play, and playfully deflects Anna's advances, rather than rejecting them abruptly. As Anna becomes more persistent in the restaurant, Giulia just finds it more and more amusing. In the couple's hotel room, Giulia laughs happily at the prospect of nude play in the snow and on noisy bed springs in Savoy, while Marcello listens anxiously, and on the soundtrack the ominous chord of the background music starts up. His honeymoon night on the train consists of the superimposition of romantic music and a picture-postcard sunset onto his re-enactment of Perpuzio's rape of Giulia. His lovemaking with Anna in the side room of the dancing school is cast in an alienating blue light which Bertolucci intended to imply the 'slaughterhouse' – while, in the room next door, children are playfully dancing. Marcello imitates the ballet students' curtsey in what at first seems a playful way, but which is in fact a ruse to yank Anna into the next room. In other words, play is used as part of the code to express the ambiguity and levity in sexual relations that Marcello cannot tolerate, and from which he is fleeing into a refuge of 'normality'. Dance, with its mixture of the erotic, the aesthetic and the ritual, is the supreme image of the *opposite* of

Marcello. One of the students in Quadri's apartment asks Marcello if dancing is still permitted in Italy under the fascist regime. The scene which very clearly opposes Marcello to Giulia, Anna and Quadri is the one in which they all go to a dance hall at Joinville.

The familiar panes of glass abound, because the external walls of the dance hall are glazed, and the meaning of the episode is partly articulated by the opposition implied in people or groups of people being on different sides of the glass. Inside, the light has a warm amber tone; outside, and through the windows, it is cold and blue. The episode begins with the two women running along the outside wall, looking in, and as they enter, the camera cuts to a position inside the door. As they prepare to dance, the camera shows the two men in the background outside looking in.
The women dance together, and Marcello tells Quadri (they are inside now) to make them stop, to which Quadri replies, *Why? They are so beautiful.* Quadri assigns aesthetic value to what Marcello wants repressed. Bertolucci dismissed as not to be taken seriously questions about the shot of the two men taken from outside looking in, with the camera tracking in close on a photo of Laurel and Hardy in the corner of the window. In Moravia's novel,

Colour temperature contrasts at the Joinville dance hall. Note the focus of the camera: on the observers of the spectacle, outside the window, rather than on the spectacle itself

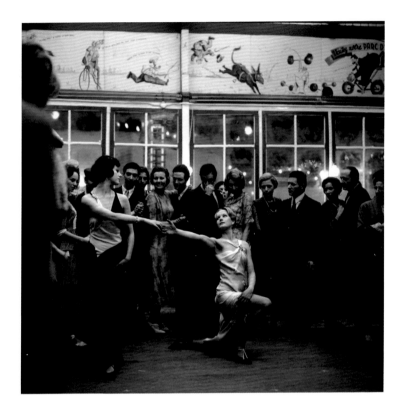

rather than a dance hall, the two couples visit a *boîte* frequented and staffed by lesbians, where the staff wear black tie, and where everybody recognises and welcomes Anna (called Lina in the novel to emphasise her doubling of Lino) as a much appreciated regular; while in Robert Aldrich's 1968 film, *The Killing of Sister George*, the lesbian couple, George and Childie, go to a lesbian bar dressed as Laurel and Hardy. Bertolucci might be discreetly and wittily expressing solidarity with Aldrich's bravery in making his film. Aldrich had problems with censorship, and when, later, so did Bertolucci with *Last Tango in Paris*, the two were interviewed in conversation on the topic (see note 39).

Marcello: 'Make them stop!' Quadri: 'They are so beautiful'

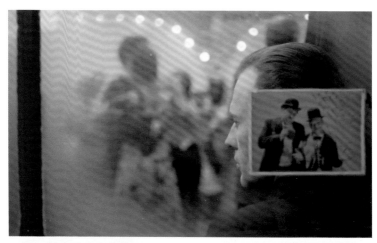

After exhibiting themselves in a tango (one of Bertolucci's many), the women start a farandole, in which all the dancers join hands in a long, curling line. The camera returns to a position showing the two men at a table with the windows of the hall behind them. The end of the farandole sweeps past and picks up Quadri. In this shot, Giulia passes by at the head of the farandole on the outside of the window behind Marcello (the familiar

Laurel and Hardy at Joinville; Childie (Susannah York) and George (Beryl Reid) in Robert Aldrich's *The Killing of Sister George*

superimposition, and once again the pane of glass separating ethical realms), at which point the camera starts to track along the glass wall parallel to the dancers outside, going round the building, with the empty tables passing by in the foreground. Finally, the track gets to the end of the window, and Giulia passes out of sight behind the frame; in the foreground, sitting at another table, is Manganiello.

Giulia at the head of the farandole goes round the outside of the building ... discovering Manganiello

The beginning and the end of the shot are symmetrical, with the playful in the background on the other side of the window, onto which is superimposed the image of death: *Eros* and *Thanatos*. The rhetorical effect of suddenly and unexpectedly encountering Manganiello is a device from the genre of the thriller which Bertolucci employs throughout the film. Marcello's repression of the libido is expressed by his walking across the empty dance floor to Manganiello and handing him the address to which Quadri will drive the following day. As he does so, in the background Quadri disappears behind Manganiello, at the end of the line of dancers (you can see Jean-Louis Trintignant repeatedly checking that his walk across the floor is synchronised with the dancers outside). At this point, the dancers return with their farandole, but the angles that the camera shoots them from keep in frame Manganiello rising, putting on his gloves and walking out of the building: the dancers entering and swirling around Marcello (who is at that point re-crossing the dance floor) are superimposed on Manganiello's slow, purposeful exit. As the dancers tighten their spiral around the stiff and anxious figure of Marcello, the soundtrack is not synchronous; instead of the clattering of many feet, we hear the orderly stamping of marching

The marching feet of the farandole tighten around Marcello

feet signifying, says Bertolucci, the impending war, and constituting a
quotation from Renoir's *La Règle du jeu*.[39] Unfortunately, there is no
farandole in *La Règle du jeu*, and Renoir's condemnation of '*le bruit
des pas*' comes from the mouth of Maréchal in *La Grande Illusion*
(1937). It is not important, because no quotation is necessary here.
The composition of the image, the movement in time and space of the
characters and of the camera, the lighting, colour and sound, the
cinematography and the dramaturgy, all unite in the formal
symmetry of dance.

The image of Marcello hemmed in by the dancers will be
repeated in the epilogue when the jubilant marchers singing *Bandiera
Rossa* and *L'Internazionale* surge round him. There is also the familiar
superimposition of one film on another in the dance-hall scene. For just
as in *Il conformista* the fascist is marked by being the only one on the
dance floor who is not dancing, in *Strategia del ragno* Athos senior is
marked as anti-fascist by the fact that he is the only one who *does*
dance to the anthem *Giovinezza*. Both the scene of Marcello in the
midst of the dancers and the scene of him among the singing marchers
in the epilogue are visualisations of his political relationship with a life
that *Bertolucci's* structure (and in this it is diametrically opposed to
Marcello's fantasy structure) posits as a 'norm' – beautiful (in Quadri's
words) and happy. It is in this context that it is important to remember
that Bertolucci wishes to criticise Quadri for being a bourgeois activist
from a safe exile, that he has earlier shown the anti-fascist Anna
shopping at a couturier's while poor people sell violets and sing hymns
to '*les damnés de la terre*', and also that he is interested less in fascism
than the bourgeoisie, and less in politics than in a psychological
condition. The norm that the film opposes to the one Marcello seeks is
by no means portrayed as unproblematic.[40]

The music of the Joinville dance hall forms a bridge to a close-
up shot through the windscreen of the car of Marcello dozing, and
then stops on the cut to a long shot of the car. Bertolucci then deploys
a procedure developed and refined by Sergio Leone (for whom
Bertolucci co-wrote the story of *Once upon a Time in the West*,

1968): a rapid piling up of repeated close-up cutaway and reaction shots to hold up the narrative. Manganiello lights a cigar and sings *Ma la mitragliatrice non la lascio* (a song about death in the Abyssinian War). Marcello recounts his dream. The camera rack-focuses between Marcello or Manganiello and the windscreen wipers. The car catches up with the Quadris, and three cars stop. Nothing at all happens for over a minute, during which windows mist up and there are nineteen shots, starting with a crane shot pulling back, rising up and over Manganiello's car and ending with Quadri getting out of his car. After a further minute, the assassins appear out of the trees.

In Moravia's novel, Orlando (the Manganiello character) tells Marcello, who is not present at the assassination, about Anna (Lina in the novel):

But what upset me most was the case of the wife, who had nothing to do with it, and who wasn't supposed to die ... but who threw herself in front of her husband to protect him, and so took two bullets intended for him. He ran away into the woods where that brute Cirrincione caught up with him ... She was still alive and I, then, had to finish her off ... She had more courage than a lot of men I've known.

The bourgeoisie and the struggle for social justice: Anna, Marcello and the seller of violets

Moravia's Lina/Anna is concrete and brave. Bertolucci tells a very different story. As the assassins approach Quadri, Anna pulls the car door closed and huddles inside her coat. As Quadri is stabbed, Anna tries to block out the vision with her hands photographed through the windscreen with the wiper in the foreground (in the same way that *Marcello* has been photographed throughout the film).

Savoy: the three cars stopped; Anna through the windscreen

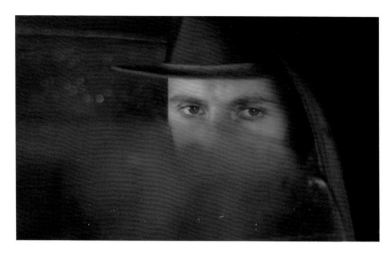

Marcello in the other car watches blankly, wiping away mist,
winding down part of his window. If we relate this *thematically* to
the rest of the film, the motif of windows (established by what we
have seen hitherto) enables us to 'read' the reverse-angle sequence –
between the stabbing and Anna watching – as *Marcello's* fantasy
point of view on the killing of the father: seeing through confusion
(misted up); wiping away the mist (to see better); hiding one's eyes
(not to see, to repress).

The killing of Anna is coloured not only by Marcello's point of
view on it, but also by the ambiguous and uncomfortable point of
view which Bertolucci sets up for the viewer of the film by offering us
an erotic dream. Marcello becomes impotent, taking no responsibility
for anything. As Anna is attacked, he picks up and arms his pistol.
She comes to his car, looks in at his window with an expression
skilfully transforming itself into one resembling that of a Gorgon,
calls him *bâtard* and runs off. A detailed shot of his pistol on the seat
beside him develops into the familiar crane shot, this time of
Manganiello looking down at the pistol in contempt, getting out of
the car and having a pee at the side of the road, cursing cowards,
queers and Jews.

Marcello observes the killing of Quadri

The actual shooting of Anna is assembled from five components: the sequence of her running through the trees (clearly echoing the ending of Truffaut's *Tirez sur le pianiste*); then the handheld-camera sequence of the chase and the shooting; then a climactic sequence in which she staggers and falls supine on the ground; followed by a post-coital 'let down' as the men walk away, their footsteps in the snow, the creaking of the trees, a cough, and then the abrupt voiceover, *Attenzione!*; acting as sound bridge, this brings us back to the EIAR of state radio (note once again the pattern of starting a new scene with a vocal, verbal imperative) and to the complete contrast of Marcello's daughter, signifying the normality which those murders have bought for him.

The cars, psychoanalysis, transference … we are watching things take place in Marcello's unconscious during a metaphorical psychoanalytical session. It is important that he never gets out of the car, that the car stands apart; he is portrayed sitting in the back, pushing his back into the seat. A double allegorical structure is assembled, in which the assassination is part of a psychoanalytical session. Marcello's psychic participation in the killing of the Quadris by fascist assassins *refers*, allegorically, to: 1) the

The woman judging the man: Anna as Gorgon

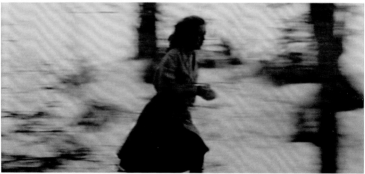

psychoanalytical process of transference, in which the struggle
between patient and analyst enacts and brings to consciousness the
repressed oedipal struggle (remember, Marcello has just recounted
his oedipal dream to Manganiello, who responds mockingly:
'*l'amore* ...'), and the killing of the father; 2) the relationship
between the viewer and the film. I would hypothesise, in the
shooting and assembly of the film, a sort of libidinal process
emerging, and Bertolucci going with the flow without necessarily
being entirely consciously aware in advance of exactly what he is

Anna running through the woods from her assassins; Léna (Marie Dubois) running
through the woods from her assassins in Truffaut's *Tirez sur le pianiste*

doing and why he is doing it – but liking the result, and so keeping
it (which is exactly how he describes his working method).
The assassination scene must be one of the most important scenes in
the film, and yet it is a scene about which critics have written little.
It is difficult to write about, because it is so uncomfortable to
watch. Could we have a better example of the director doing to the
viewer what the content of the narrative does to the protagonist?
How better could you convey artistically what it is you are
narrating than by creating in the viewer an analogue of what you
are portraying in the narrative?

Let us jump to the very last sequence of the film.
Moravia closed his novel with a *deus ex machina*. Bertolucci wanted
to end his film with the unconscious. Lino's attempted seduction of
Marcello as a child had created a disturbance in Marcello's
unconscious which he had sought to suppress. Bertolucci wanted the
film to end with Marcello facing the very thing lurking in his
unconscious that he had tried to repress. So he needed the camera to
move up the naked body of the rent boy, his legs, his bottom, his
torso, his shoulders and then his head, and arrive at Marcello, who is
standing in front of him at the entrance to his niche and hasn't seen
him yet, and who sits down with his back to the youth. He then
needed a reverse-angle close-up of the rent boy, backlit so as to make
his body only half-visible (lurking in the shadows, as it were).
He wanted the youth to wind up his gramophone and turn to look at
Marcello. And he wanted Marcello to respond to the glance by
looking back (in the next reverse angle) on what he had sought to
erase. For the first part of what Bertolucci wanted, the boy had to be
facing outwards in the niche. For the second part, he had to be facing
inwards (so as to look back at Marcello from the darkness).
The contradiction caused Bertolucci no concern; with regard to such
incongruities in his film, he would tell interviewers: 'That's what
happens when you shoot like me without continuity.'[41] His job was
to assemble expressive poetic images.

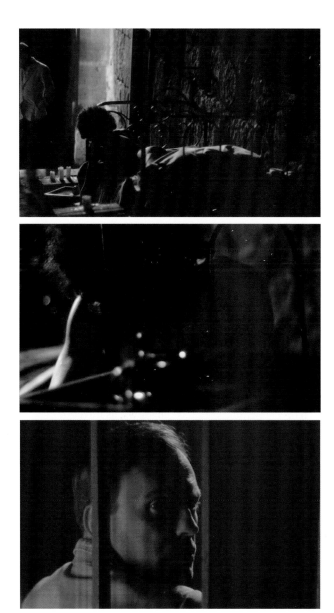

The youth in an arch of the Teatro Marcello facing *outwards*, winding his gramophone; the youth facing inwards, turning to Marcello behind him; Marcello faces something within himself

Sex and politics

Moravia's novel had four principal threads: 1) Fate as depicted in
Greek tragedy (and so Marcello seeks the sanction/cover of society
for what he's destined to do anyway); 2) Freudian psychoanalysis
(early seduction and witnessing the primal scene leads to confusion
and the attempt to suppress/repress his libido); 3) homosexuality and
concomitant guilt/stigma (and so Marcello tries to hide his
abnormality behind a façade of normality); 4) existentialism (the
feeling of existing in a meaningless void, the absurd, a moral nihilism,
combined with a lack of purpose and personal responsibility, of
which he is robbed by Fate). Bertolucci's film: 1) discards tragic Fate;
2) replaces it with a psychoanalytical representation of Marcello's
unconscious; 3) retains homosexuality and the guilt and stigma that
goes with it; 4) retains the existentialism in the form of an anxiety at
being unanchored.

In an interview about *Strategia del ragno* that he gave to writers
from an Italian film journal just before the release of *Il conformista*,
Bertolucci said:

I am curious to know what you will think of *The Conformist*. I am tempted to
show it to you as soon as possible because it's very different. There's a kind of
happiness in *Spider*; it's an entirely closed world. But I'm eager to know what
you'll think of *The Conformist*, which is a film entirely without joy, a terrible,
even a ferocious film.[42]

There is a danger of explaining away *Il conformista*. More is
expressed in the film than merely representations, opinions and ideas
about Italian history, about politics, and the working out of the
oedipal complex and gender identity. If anything, these issues are the
raw material out of which Bertolucci has fashioned poetic imagery
for an artefact that stands with and surpasses its twin (they were born
together), *Strategia del ragno*. The first, *Strategia*, uses many of the
same raw materials I have just listed above to fashion poetic images
for confusion and bewilderment in the face of an account of reality

imposed on us by our personal and social history. The second, *Il conformista*, angrily strips away the façade from the illusions with which we upholster a world we experience as offering no meaning or support. That is what a poet does; he fashions a beautiful object by expressing himself.

In the UK and the United States, *Il conformista* is regarded as deploying psychoanalysis to make serious and interesting points about sexuality and fascism.[43] However, I cannot entirely dismiss a suspicion that psychoanalytical *interpretations* of works of art (as opposed to analyses of the intellectual *structure* of a work) can lend themselves to improvisation. This can be great fun, and to illustrate it I have taken the liberty of quickly knocking off an 'interpretation' of *Il conformista* over my lunch break:

The prostitute figures and Anna all 'belong' to men of power and authority, father figures for Marcello. These women, played by Sanda, could be seen as the father's phallus, which Marcello wants to possess. The Sanda-women's being the fathers' phallus makes them simultaneously projections of anxiety about Marcello's own phallus. He consummates his marriage in a re-enactment of Giulia's rape by a father figure called Perpuzio (penis). Manganiello's name (*manganello* = fascist cudgel) makes him a paternal penis too. Alberi (a phallic symbol by virtue of his name, 'tree') penetrates Marcello's mother with a syringe, and more. Alberi recalls Lino, who was slender and phallic (both were uniformed and wore a military-style cap), and had a pistol Marcello wanted, and possessed, and used – on Lino. Marcello has the phallic Manganiello 'repress' Alberi (he starts by removing the long cigar from his mouth), and then becomes a penis, straight and stiff himself, scuttling up the steps back into his mother's house (the entrance perhaps reminiscent of something else). However, Marcello's designs on the phallus of the father invite the punishment of castration, and so Manganiello has the penis-fetish of Anna Quadri cut down by men emerging from a forest of phallic superiority while pulling out his own phallus (to take a pee) and denying Marcello's virility (by calling him a cowardly homosexual). *Il conformista* is a film about castration anxiety.

This reading of the film is not implausible, but whom are we psychoanalysing by interpreting the symbolism? Not Marcello, because he only exists in the language of which he is created; to 'psychoanalyse' him is merely to list the components from which he is assembled. To suggest that we understand Bertolucci by psychoanalysing Marcello is not only implausible but offensive. On the one hand, the critical procedure fails to touch upon what is most interesting about *Il conformista*. But on the other hand, I do seem to have stumbled onto something in my lunch break. I thought it was me who was having fun. Instead it was Bertolucci.

There is no respectable argument for linking fascism with homosexuality, and Bertolucci himself has never made the link. He describes the film as being about a man who believes himself to be different from his fellows, who thinks he is a murderer and possibly homosexual, and tries to hide this abnormality behind conformity to a social and political norm which at every turn reveals itself to be illusory. Bertolucci's point lies in the parallel between, on the one hand, the way the bourgeoisie thinks about itself and the reality that hides behind that façade; and on the other, the complacent rhetoric of the fascist regime and the naked violence of the class war which the rhetoric concealed.

The very fact of making homosexual anxiety a component of the abnormality which Marcello wishes to hide raises the question of the sexual politics of social norms. Upon the fall of Mussolini, Marcello finds and denounces Lino as the murderer of the Quadris and as 'a fascist, a pederast' (not so much homosexual as child molester), and in his haste to conform to a new norm is made to denounce his erstwhile friend Italo as a 'fascist' (but not as homosexual), because it is fascism that has now become a manifestation of abnormality. The association of Fascism and Nazism with homosexuality is a perspective in which homosexuality is seen as an encoding of their moral or political acceptability, rather than merely as a matter of sexual orientation. Italian culture has, since the Middle Ages and under the influence of the Church, used

sex as a political and moral code: Italy as a distressed noblewoman reduced to the status of a servant, to be saved only by the virility of her menfolk tempered in blood and war. Those who plunder her are decadent and effeminate. In the Italian cinema, this perspective is most emphatically launched by Rossellini's film *Roma città aperta* (*Rome, Open City*) in 1945, in which the male Gestapo officer is homosexual and his female colleague is lesbian. Rossellini has to answer for initiating a whole Italian cinematic tradition. Bertolucci is not so much examining questions of sexual politics as deploying a conventional cinematic iconography. He is doing so at a historical moment in which that iconography is being deployed in many and varied ways, some of them no less conventional than his (and I have mentioned a few towards the beginning of this book). For many people nowadays, fascism represents the manifestation of a psychological illness, a neurosis. In other words, it was pathological. This is a convention that originates among artists. In actual fact, fascists were normal, pleasure-loving Italians. So *Il conformista* and films like it have acquired a power from our desire to repress fascism, from our fear and demonisation of fascism, rather than from any particularly accurate representation they might give of fascism itself. As viewers of *Il conformista*, we enact the very same desperate search for norms and frightened repression of abnormality that the protagonist does in the narrative.

To draw a parallel between repressing doubts about one's sexuality and conforming to conservative nationalist authoritarianism is legitimate poetic licence, provided interpretation goes no further than that. With psychoanalysis, any strenuous desire to go in one direction is interpreted as repression of a 'real' desire to go in the other direction, which has led to interpretations of Fascism and Nazism as pathological products of 'repression'. Nor, in truth, is *Il conformista* entirely coherent and unambiguous.
In psychoanalytical theory, to repress something is to keep it from ever becoming conscious; hiding one's sexual orientation from others is not repressing it. One of the functions of the character Italo is to

make explicit Marcello's doubts about his sexual orientation. Italo himself, a broadcaster employed by the regime, is shown as expressing no need to hide his own homosexuality, though he is, incongruously, made to regret it (at the stag party). Ettore Scola's film of 1977, *Una giornata particolare* (*A Special Day*), shows precisely how vulnerable such a figure is to persecution by the regime. Early in the film, Marcello confesses to no homosexual acts, while we learn in the epilogue that Marcello and Italo's 'usual meeting place' is a pickup point for rent boys. The best we can say is that Bertolucci's replacement of Moravia's Fate by the Freudian unconscious, and his linking it with political conformism, offers rich scope for a metaphorical illustration of how all norms (which are by definition political impositions) dissolve under scrutiny.

Bertolucci's oeuvre taken overall (in an auterist approach à la Andrew Sarris) does have what one could call a kind of sexual politics: in the way that his male characters are judged negatively from the perspective of his female characters. And this is bound up with the oedipal complex. That is to say, the males compete in an oedipal struggle, and the females observe and are appalled. Therefore, blame and shame belong to men, and are attached to them by the presence of observing women. The women are, if you like, the mirrors in which the men see their own shame. And very often, their shame is accompanied by a sexual inadequacy (a breathtaking example is the episode of the wedding in the 1976 film *1900*). It is interesting to observe how Anna is photographed. Most of the time, she is photographed looking, very often towards the camera, which is Marcello. In the assassination scene, she is looking at Quadri's assassination; but you could see that as her looking at Marcello, because the assassination is Marcello's fantasy. If Anna is photographed looking, then you could say that she functions as the look in the film, and it is a judgmental look. In a powerfully understated scene in the epilogue, Giulia too adopts this kind of look.

From his youthful love affair with the French *nouvelle vague*, Bertolucci inherited a Brechtian concern with an issue best articulated

by Godard's Dziga Vertov group: 'The problem is not to make *political* films, but rather to make films *politically*.' An aspect of this concern surfaces in the continual self-reflexivity of *Il conformista*. It is often about cinema, as well as being about whatever else it is about. Into the story Bertolucci continually inserts references to cinema, suggesting that cinema is now, and perhaps always was, what fascism was in Italy: the offer of a fantasy wish-fulfilment vision to replace reality (which is Freud's definition of a dream). *Il conformista* is a supremely beautiful artefact. But it brings the viewer no nearer to understanding any but the most orthodox sexual orientation. And while its theme of conformism might, on a very superficial level, contribute to explaining why the fascist regime was so tolerated by a politically indifferent Italian populace, it contributes little to an understanding of the politics of fascism and its savage consequences in a historical moment. Perhaps what it does do is illustrate the extent to which all 'messages' are made of 'images', and all images are illusions projected on one kind of screen or another: the more attractive the image, the more illusory. In which case, however suspicious Jean-Luc Godard may have been about the work of his oedipal assassin, he ought to have appreciated that *Il conformista*'s shortcomings as a political film derive in large part from how politically it was made.

Notes

1 See Alberto Moravia, *Intervista sullo scrittore scomodo*, edited by Nello Ajello (Bari: Laterza, 1978), *passim*; and Enzo Siciliano, *Moravia* (Milan: Longanesi, 1971), pp. 75–96.
2 Jean-Paul Sartre, 'L'Enfance d'un chef', in *Le Mur* (Paris: Gallimard, 1939).
3 Interview in Stefano Masi, *Nel buio della moviola: introduzione alla storia del montaggio* (L'Aquila: La Lanterna Magica, 1986), reprinted in the booklet accompanying the Minerva RaroVideo DVD of *Il conformista*.
4 Gian Luigi Rondi, 'Bertolucci: The Present Doesn't Interest Me', *Il Tempo*, 2 January 1983, reprinted in Fabien S. Gerard, T. Jefferson Kline and Bruce Sklarew (eds), *Bernardo Bertolucci Interviews* (Jackson: University Press of Mississippi, 2000), p. 168.
5 Quoted in Richard Kelly, 'Ferdinando Scarfiotti 1941–1994: Excursions into Style', *Critical Quarterly*, vol. 38, no. 2, June 1996, pp. 3–32.
6 Fred Hughes, 'Interview with Ferdinando Scarfiotti: Art Director of *Death in Venice*', *Andy Warhol's Interview Magazine*, March 1971, quoted in Kelly, 'Ferdinando Scarfiotti'.
7 Interview in Gabriele Lucci, *Cineasti e scenografi del cinema italiano* (L'Aquila: La Lanterna Magica, 1990), reprinted in the booklet accompanying the Minerva RaroVideo DVD of *Il conformista* (italics in original).
8 Bertolucci interviewed on the Minerva RaroVideo DVD of *Il conformista*.
9 Enzo Ungari (ed.), *Scene madri di Bernardo Bertolucci* (Milan: Ubulibri, 1982), p. 72, translated by Don Ranvaud, in Enzo Ungari and Don Ranvaud (eds),

Bertolucci by Bertolucci (London: Plexus, 1987), p. 72 – but I have preferred my own translation.
10 Marilyn Goldin, 'Bertolucci on *The Conformist*', *Sight & Sound*, vol. 40, no. 2, Spring 1972, reprinted in Gerard, Kline and Sklarew (eds), *Bernardo Bertolucci Interviews*, pp. 63 ff.
11 ORTF, 26 February 1971, in the booklet accompanying the Minerva RaroVideo DVD of *Il conformista*.
12 Jean A. Gili, 'Bernardo Bertolucci', *Le Cinéma italien* (Paris), vol. 10, no. 18, 1978, reprinted in Gerard, Kline and Sklarew (eds), *Bernardo Bertolucci Interviews*, p. 121.
13 Ungari (ed.), *Scene madri di Bernardo Bertolucci*, p. 72.
14 Gili, 'Bernardo Bertolucci', p. 132.
15 Goldin, 'Bertolucci on *The Conformist*', p. 65.
16 'Bernardo Bertolucci', *Dialogue on Film*, vol. 3, no. 5, Spring 1974, p. 19.
17 A. Tassone, *Parla il cinema italiano*, vol. 2 (Milan: Il Formichiere, 1980), p. 61.
18 'Dialogue on Film, Bernardo Bertolucci', *American Film*, January–February 1980, p. 41.
19 Alfredo Barberis, 'Making Movies? It's Like Writing Poetry', *Il Giorno* (Milan), 19 August 1962, reprinted in Gerard, Kline and Sklarew (eds), *Bernardo Bertolucci Interviews*, p. 7.
20 Roberto Campari, 'Viaggio attraverso il cinema', in Roberto Campari and Maurizio Schiaretti (eds), *In viaggio con Bernardo: il cinema di Bernardo Bertolucci* (Venice: Marsilio, 1994), p. 15.
21 Andrea Sabbadini (ed.), *The Couch and the Silver Screen: Psychoanalytic Reflections*

on *European Cinema* (Hove and New York: Brunner-Routledge, 2003), p. 20.

22 Louis Marcorelles and Jacques Bontemps, 'Interview with Bernardo Bertolucci', *Cahiers du cinéma*, March 1965, reprinted in Gerard, Kline and Sklarew (eds), *Bernardo Bertolucci Interviews*, p. 11.

23 Tassone, *Parla il cinema italiano*, p. 74.

24 Adriano Aprà, Maurizio Ponzi and Piero Spila, 'Bernardo Bertolucci: *Partner*', *Cinema e film* (Rome), nos. 7–8, Spring 1968, reprinted in Gerard, Kline and Sklarew (eds), *Bernardo Bertolucci Interviews*, pp. 39–40.

25 Elias Chaluja, Sebastian Schadhauser and Gianna Mingrone, 'A Conversation with Bertolucci', *Filmcritica*, no. 209 (Rome), October 1970, reprinted in Gerard, Kline and Sklarew (eds), *Bernardo Bertolucci Interviews*, p. 60.

26 Storaro's explanation comes from an interview on the Paramount DVD of *The Conformist* (2006); Bertolucci's from Ungari (ed.), *Scene madri di Bernardo Bertolucci*, p. 73.

27 Francesco Casetti, *Bernardo Bertolucci* (Florence: La Nuova Italia, 1975), p. 5.

28 Goldin, 'Bertolucci on *The Conformist*', pp. 64–6.

29 *Cinéma 71*, no. 155, 1971, pp. 114–20.

30 Ungari (ed.), *Scene madri di Bernardo Bertolucci*, pp. 72 ff.

31 *The Conformist*, Paramount DVD Extras (2006).

32 Goldin, 'Bertolucci on *The Conformist*', p. 65.

33 See S. Kracauer, *Theory of Film: The Redemption of Physical Reality* (New York: Dobson, 1960).

34 Quoted in M. Morandini, *Il cinema di Bernardo Bertolucci* (Bergamo: Quaderni del Cineforum di Bergamo, 1973), p. 39.

35 Tassone, *Parla il cinema italiano*, p. 74.

36 I shall directly translate Bertolucci's original Italian dialogue, rather than use the English dubbing or subtitles.

37 This, and a number of other points about this sequence, are discussed in an illuminating article: A. Britton, 'Bertolucci: Thinking about Father', *Movie*, no. 23, 1976/7, pp. 9–22.

38 A list of sheets of glass and mirrors, or viewing apertures, in the film: 1) mirror in opening shot in hotel room; 2) glass doors of hotel in second shot of film; 3) front windscreen of car in shot 8; 4) window of radio studio; 5) mirror in Giulia's mother's apartment; 6) Manganiello's car 'tailing' Marcello; 7) the windows of Marcello's mother's car; 8) the grille of the confessional; 9) windows of train; 10) the 'see-through' Magritte painting; 11) rear window of Lino's car; 12) window of Lino's bedroom; 13) mirror in Quadri's conservatory; 14) windows in Quadri's study; 15) windows in Giulia's taxi for the Eiffel Tower; 16) mirror in dancing school; 17) shop window and glass doors of the Jacques Heim store in Paris; 18) crack in the doorway of Marcello's hotel room through which he watches Anna and Giulia; 19) windows of the dance hall; 20) the steamed-up windows of the three cars during the assassination. They can function as barriers which emphasise the separation or difference of the observer from the observed, the desirer

(or fearer) from the desired (or feared), or as 'screens' on to which fantasies are projected or behind which reality is concealed. In a similar vein, there is quite a catalogue of 'bars' through, or from behind which, events are watched.

39 'Bernardo Bertolucci', pp. 21–2; for the conversation between Bertolucci and Aldrich, see Robert Aldrich and Bernardo Bertolucci, 'Dialogue', *Action*, vol. 9, no. 2, March 1974, pp. 23–5.

40 *Cinéma 71*, p. 115; and Tassone, *Parla il cinema italiano*, p. 65.

41 'Bernardo Bertolucci', p. 25.

42 Chaluja, *et al.*, 'A Conversation with Bertolucci', p. 60.

43 Bertolucci himself approved highly of Kline's very fine psychoanalytically inclined critical study of his work: T. Jefferson Kline, *Bertolucci's Dream Loom: A Psychoanalytical Study of Cinema* (Amherst: Massachusetts University Press, 1987).

Credits

**Il conformista
(The Conformist)**
Italy/1970

Directed by
Bernardo Bertolucci
Producer
Maurizio Lodi-Fè for
Mars Film
Executive Producer
Giovanni Bertolucci
Screenplay
Bernardo Bertolucci
Adapted from the novel
Il conformista by Alberto
Moravia, written in 1949,
published by Valentino
Bompiani, 1951
Cinematographer
Vittorio Storaro
Editor
Franco Arcalli

**Co-Production
Companies**
Mars Film (Mars Film
Produzione S.p.A., Rome)
Marianne Productions
(Paris)
Production Participation
Maran Film (Maran Film
G.M.B.H., Munich)
**Production
Designer/Art Director**
Ferdinando Scarfiotti
Costume Designer
Gitt Magrini
**Original Music
Composed and
Conducted by**
Georges Delerue

Songs by
Cesare Andrea Bixio
(*Chi è più felice di me!*)
Bruno Quarantotto,
Enrico Frati (*Come l'ombra*
performed by Trio
Lescano)
Set Decorator
Osvaldo Desideri
Make-up
Franco Corridoni
Hairstylist
Rosa Luciani
Production Manager
Serge LeBeau
Production Supervisors
Aldo U. Passalacqua
Mario Cotone
Nicola Venditti
Assistant Directors
Aldo Lado
Alain Bonnot
Paolo Finocchi
Assistant Art Director
Nedo Azzini
Sound
Mario Dallimonti
Sound Mixer
Franco Bassi
**Sound Re-recording
Mixer**
Guido Giogucci
Camera Operator
Enrico Umetelli
Assistant Camera
Giuseppe Alberti
Electrician
Alberico Novelli
Assistant Costumer
Piero Cicoletti

Assistant Editors
Vincenzo Di Santo
Giancarlo Venarucci
Production Secretaries
Loredana Pagliaro
Attilio Viti
Script Girl
Flavia Sante Vanin
Administrator
Pietro Sassaroli

CAST
Jean Louis Trintignant
(dubbed by Sergio
Graziani)
Marcello Clerici
Dominique Sanda
(dubbed by Rita
Savagnone)
Anna Quadri
The Minister's mistress
Prostitute at Ventimiglia
Stefania Sandrelli
Giulia
Gastone Moschin
Manganiello
Enzo Tarascio
Professor Luca Quadri
Fosco Giachetti (dubbed
by Arturo Dominici)
The Colonel
José Quaglio (dubbed by
Giuseppe Rinaldi)
Italo Montanari
Pierre Clémenti
Lino (Pasqualino
Semirama)
Yvonne Sanson (dubbed
by Lydia Simoneschi)
Giulia's mother

Milly
Marcello's mother
Giuseppe Addobbati
Marcello's father
Christian Alegny
Raoul
Carlo Gaddi
Umberto Silvestri
Furio Pellerani
Luigi Antonio Guerra
Orso Maria Guerrini
Claudio Cappeli
Assassins
Pasquale Fortunato
Marcello as a boy
Antonio Maestri
Confessor
Alessandro Haber
Senigallia, drunk blind
man at stag party
Massimo Sarchielli
Blind man at stag party
who fights with
Senigallia
Pierangelo Civera
Franz
Gianni Amico
Joel Barcellos
Giorgio Pelloni
Luciano Rossi
Students of Professor
Quadri
Christian Belegue
Gipsy
Benedetto Benedetti
Minister
Gino Vagniluca
Secretary of Minister
Romano Costa
Man opening the door

Marta Lado
Marcello's daughter
Marilyn Goldin
Seller of violets
Christian Bélègue
Rent boy

Distributed by
Paramount Films of Italy
Inc., Paramount Pictures

The film was shot
between October 1969
and January 1970. For its
first showing, at the
Berlin Film Festival in
June 1970, a four-minute
episode, that of the stag
party, was cut from the
film to shorten it, and
was discarded, and that
shortened version was
the one that went on
general release in
October 1970. Bertolucci
confessed, before it was
rediscovered, his regret
at the loss of the scene.
In an interview on the
2006 Paramount DVD,
Vittorio Storaro explains
that: 'A few years ago,
Paramount ... asked me
to transfer the film onto
tape.' He was using the
original negative, and the
scene was still there.
'The matrix had been
cut, but not the negative.'
He immediately called
Bertolucci and told him

what he had discovered.
Bertolucci said that the
scene's survival meant
that it was obviously
destined to be in the
film. This full version
was presented at the
Locarno Film Festival in
August 1993 and
re-released in 1994.
In 1994, *Sight & Sound*
gave its length as
113 minutes. In the
Paramount DVD, its
length is 111 minutes,
but much of the end
credits and most of the
song *Come l'ombra* that
continues after the end
credits have rolled are
missing. The Cineteca di
Bologna together with
Minerva RaroVideo
carried out a digital
restoration of the film in
2011, supervised by
Vittorio Storaro, paying
particular attention to
colour correction and the
soundtrack.
This restored version
was first shown in the
Cannes Classics section
at the Cannes Film
Festival in May 2011, in
June at the Bologna
Festival, and was released
in August. The Cineteca
di Bologna gives its
length as 118 minutes.
The Minerva RaroVideo

DVD version is given as 112 minutes 45 seconds. Play it on a British DVD player, and it will be 108 minutes 14 seconds. Arrow Films' specifications are helpful: DVD: 108 minutes 12 seconds; Blu-Ray (24Psf): 112 minutes 51 seconds.

DVD

The Conformist Extended Edition, Paramount Home Video 08121, USA, 2006, Region 1 DVD NTSC (remastered version). *Il conformista*, Minerva RaroVideo RVD 40335, Italy, 2011 (digital restoration by the Cineteca di Bologna).

(In both cases, full version with Italian and English dialogue, and English subtitles.) *The Conformist*, Arrow Films FCD500, UK, 2012, dual-format DVD and Blu-Ray (Italian dialogue with optional English subtitles).

Select Bibliography

Britton, Andrew, 'Bertolucci: Thinking about Father', *Movie*, no. 23, 1976/7, pp. 9–22.

Campari, Roberto, 'Viaggio attraverso il cinema', in Roberto Campari and Maurizio Schiaretti (eds), *In viaggio con Bernardo: il cinema di Bernardo Bertolucci* (Venice: Marsilio, 1994).

Casetti, Francesco, *Bernardo Bertolucci* (Florence: La Nuova Italia, 1978).

Gerard, Fabien S., T. Jefferson Kline and Bruce Sklarew (eds), *Bernardo Bertolucci Interviews* (Jackson: University Press of Mississippi, 2000).

Kline, T. Jefferson, *Bertolucci's Dream Loom: A Psychoanalytical Study of Cinema* (Amherst: Massachusetts University Press, 1987).

Kolker, Robert, *Bernardo Bertolucci* (London: BFI, 1985).

Magny, J., 'Dimension politique de l'oeuvre de Bernardo Bertolucci de *Prima della rivoluzione* à *Novecento*', *Etudes Cinématographiques*, nos. 122–6 [monographic issue] (Paris: Minard/Lettres Modernes, 1979).

Marcus, Millicent, *Italian Film in the Light of Neorealism* (Princeton, NJ: Princeton University Press, 1987).

Morandini, Morando, *Il cinema di Bernardo Bertolucci* (Bergamo: Quaderni del Cineforum di Bergamo, 1973).

Prono, Franco, *Bernardo Bertolucci: il conformista* (Turin: Lindau, 1998).

Tonetti, Claretta, *Bernardo Bertolucci: The Cinema of Ambiguity* (New York: Twayne/London: Prentice Hall International, 1995).

Ungari, Enzo (ed.), *Scene madri di Bernardo Bertolucci* (Milan: Ubulibri, 1982), translated by Don Ranvaud, in Enzo Ungari and Don Ranvaud (eds), *Bertolucci by Bertolucci* (London: Plexus, 1987).